CowParade: The Cows Come Home

WEST HARTFORD • CONNECTICUT

cow parade

CowParade Holdings Corporation

ORANGE FRAZER *PRESS*
Wilmington, Ohio

Additional copies of *CowParade: The Cows Come Home* may be ordered directly from:
Orange Frazer Press
P.O. Box 214
Wilmington OH 45177

Telephone 1.800.852.9332 for price and shipping information
Website: www.orangefrazer.com

Library of Congress Control Number: 2003113837

Printed in Canada

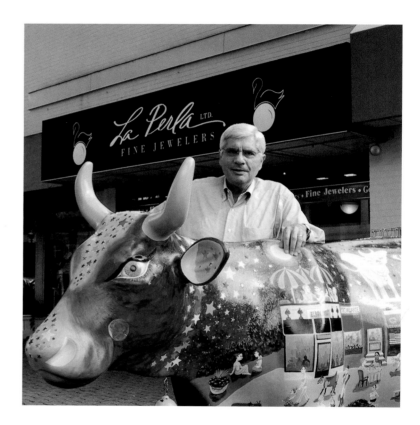

Jerry Elbaum
President, CowParade

OUR UNIQUE BREED OF COWS HAS MOOVED HOME to West Hartford where CowParade had its origins nearly five years ago. They are the ingenious offspring of our herds of bodacious bovines which have grazed on the sidewalks and plazas of New York, Chicago, London, Tokyo, Houston, Brussels, Atlanta, Dublin, San Antonio, Auckland and Kansas City. These colorful and whimsical creatures have brought smiles to the faces of millions of people around the globe. Children scamper all around, under and over these cows and, from their encounters with them, gain some appreciation of the creative energies with which they and each one of us are endowed. Our canvases are pure fun and enjoyment and provide a welcome distraction from the anxieties associated with the present world condition.

Special thanks are due to Marge Abrams, our Creative Director, who oversaw the production of the West Hartford art, which cow for cow is just about the best we ever have seen in a CowParade exhibit. The artists merit unending praise for their moovelous creations. Harriet Dobbin, who spearheaded the marketing of the event, is to be congratulated for her successful efforts. Without our many sponsors, particularly the presenting sponsor, Guida's Milk and Ice Cream, CowParade West Hartford Center would not have been possible. My thanks go to them as well as to the Town of West Hartford, which so enthusiastically welcomed and supported us, and to The Connecticut Children's Medical Center, the primary charitable beneficiary. Winston Churchill once wrote that: "We make a living by what we get; we make a life by what we give." All of us at CowParade are so pleased to be able to give to you the udder enjoyment which CowParade represents.

Jerry Elbaum
President, CowParade

Jonathan Harris
Mayor of West Hartford, Connecticut

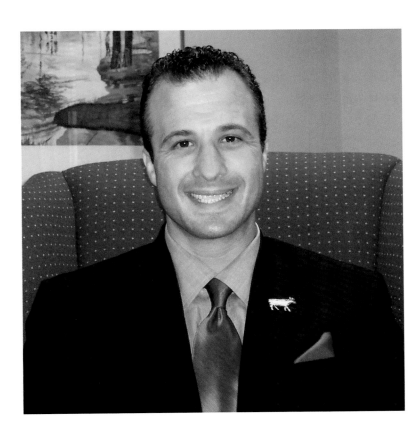

CowParade West Hartford Center has brought to our wonderful town an element of curiosity and creativity with its herd of 57 spectacular cows that showcase the talents of area artists. Our sidewalks and open spaces have been filled with these life-size fiberglass cows that have put countless smiles on faces.

CowParade, headquartered in West Hartford, has been seen by millions all over the globe. But despite all the fame and success, the place the founders of this public art-for-charity organization wanted to be most was home in West Hartford. We are honored that CowParade is part of our community and has brought the parade home. We have truly enjoyed this three-month special event.

From our outstanding restaurants to our one-of-a-kind shops, West Hartford is truly exceptional. Our town is beautifully accented with flowers, our brick sidewalks are clean, and our well-lighted streets are safe all hours of the day and night. West Hartford is the perfect setting for the cows to work their magic.

West Hartford has encouraged visitors to take their families, friends and their cameras as they observed these magnificent works of public art. We have also encouraged visitors to take advantage of all that West Hartford has to offer. CowParade has made visiting West Hartford an extra special treat.

We hope you will have fond memories of the 2003 herd of zany bovines and will participate in the auction that will benefit 40 local charities.

Kindest regards,
Mayor Jonathan A. Harris

CowParade—Moo'ving Art Around The World

CowParade® HAS CAPTURED THE HEARTS and imaginations of millions of people around the world over the past 4 years, bringing art out of the museum and onto the streets in an 'udderly unique' way.

Featuring its famous life-size cow sculptures, CowParades have literally taken over the city's of Chicago, New York, and London, just to name a few, turning their streets, parks, and other public places into stampedes of art! Each CowParade event takes on the distinct character of the city, region and its artists; the cows are merely beautiful and fun canvases on which the artists explore their city's unique culture and history, while showing off the full extent of their creativity.

The essence of CowParade is the artistic creativity it generates and the wonderful smiles brought to the faces of children and adults alike. CowParade Chicago event organizer Peter Hanig best captured the essence of the public art movement led by CowParade:

"Art is about breaking down barriers. It gets people to feel, to think, to react. So when you come across life-sized cow sculptures that have been covered in mirrors or gumdrops, cows that have been painted with elaborate themes or transformed into something else entirely, you can't help but stop and think about what it means. All your preconceived ideas go out the window. Suddenly people see that art can be fun and that art can be interesting to everyone, not just people who frequent museums."

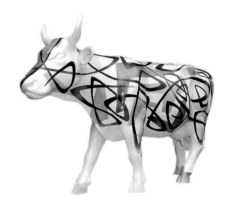

Featured in this book are CowParade's latest works on the streets of West Hartford, Connecticut, its hometown, along with a brief retrospective of past CowParades and their bovine creations.

History of CowParade.

HEADQUARTERED IN WEST HARTFORD, Connecticut, CowParade is the world's largest and premier public art event. Since

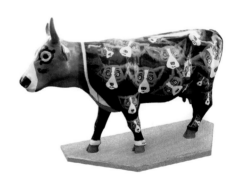

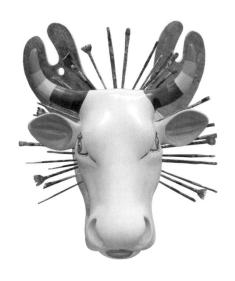

Chicago in 1999, CowParade has visited 19 cities on four continents. While the basic cow sculptures remain the same, each city's artists are challenged by the creations from past events, inspired by the culture and history of their respective cities, and moved by their own interpretation of the cow as an object of or canvas for art.

Why Cows?

THEY ARE SIMPLY UNIQUE, three-dimensional canvases to which the artists can easily relate. There is really no other animal that can adequately substitute for the cow and produce the level of artistic accomplishment evident in the 19 CowParade events. The surface area and bone structure of the CowParade sculptures are just right, as are their heights and lengths. Each form—standing, grazing, and reclining—has unique curves and angles, making them ideally suited to all forms of art. They have now been reinterpreted, altered, and morphed into over 2500 one-of-a-kind works of art by artists worldwide.

Equally important, the cow is an animal we all love. The cow is whimsical, quirky and never threatening. She provides us with milk, is the source of heavenly ice cream, and is the inspiration for one of our first words—"mooo." From early on in life, we all have a connection with the cow in one way or another.

Who are the Artists?

 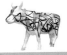 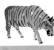

1999	2000	2001	2002	2002/2003	2003
Chicago, IL	New York, NY Stamford, CT W. Orange, NJ	Kansas City, MO Houston, TX Sydney, Australia	London, England Venspils, Latvia Portland, OR Las Vegas, NV	San Antonio, TX Auckland, New Zealand	Atlanta, GA Brussels, Belgium Dublin, Ireland Isle of Man, UK Tokyo, Japan West Hartford, CT

Who are the Artists?

COWPARADE EVENTS ARE OPEN to artists of all backgrounds and disciplines. Professionals and aspiring artists, painters and craftsman, and artists of all ages are invited to participate. CowParade events have attracted renowned and celebrity artists including Peter Max, Leroy Neiman, Patrick Hughes, Romero Britto, and Soprano's star Frederico Castellucio.

Each event begins with a "Call to Artists" inviting local and regional artists to submit designs. Parameters for the designs are set wide to encourage a broad range of art and artists. There are restrictions only against blatant advertising, political slogans, religious messages and inappropriate images. A large portfolio is created from which event sponsors select their desired artist and design. The common denominator to each event is the flood of designs that pour in as the submission deadline approaches. Sponsors' biggest challenge is picking just one design. For every official cow produced, there are ten design submissions that do not get chosen. 2500 designs were submitted for CowParade New York alone and, to date, over 10,000 artists from around the world have applied to paint a cow.

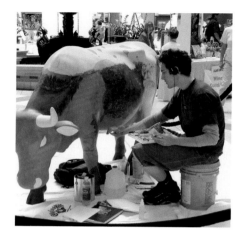

What Happens to all of those Cows?

AT THE CONCLUSION OF EACH EVENT, the cows get 'rounded up', refurbished, and sold at auction for the benefit of non-profit organizations. Premier auction houses such as Christie's, Sotheby's and Phillips Auctioneers have all conducted CowParade auctions, which have raised over $6 million thus far. The CowParade Chicago auction raised an amazing $3 million for charity, including $1.4 million from the internet auction hosted by the Chicago Tribune and $2.1 million at the live auction conducted by Sotheby's. The average bid price on the 140 cows was nearly $25,000, with the top cow, *HANDsome*, selling for $110,000. The CowParade New York live auction raised an equally impressive $1,351,000.00 benefiting several New York City charities. *Tiffany Cow* garnered the top bid at $60,000. Past auction purchasers include Oprah Winfrey, Ringo Starr, and Princess Fiyral of Jordan. CowParade London

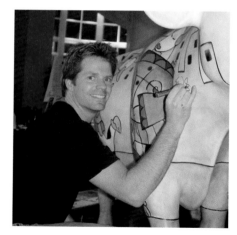

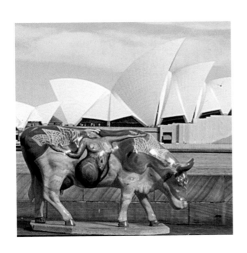

2002's auction drew a record 1500 attendees.

After the auctions, winning bidders bring the cows to their new homes. Cows have been spotted at ski resorts and beach homes, on farms and ranches, in backyard gardens and living rooms, and even building and residential rooftops. You just never know where one of the Cows will appear.

On the Horizon...

COWPARADE TRAVELS TO THE WORLD'S most exciting cities in 2004 and beyond. On the horizon are events in Stockholm, Sweden, Manchester, England, Johannesburg, South Africa and the first U.S. capital city event in Harrisburg, Pennsylvania. CowParade will moo've to South America in 2004, and after that look for cows grazing in China, Russia and other unique and exotic locations around the world.

CowParade West Hartford—The Cows Come Home

The cows truly came home in 2003 as CowParade hosted the event in its home city of West Hartford, Connecticut. Featuring over 50 original works of art created by local and regional artists, the West Hartford event drew an estimated 500,000 visitors, turning this charming, yet cosmopolitan New England city into a virtual stampede of public art. The cows, which grazed from September 3 to December 5, 2003, are ultimately sold at auction benefitting 40 non-profit organizations throughout Connecticut, including Connecticut Children's Medical Center, American Cancer Society, American Red Cross, the National Multiple Sclerosis Society, and Nutmeg Big Brothers and Big Sisters.

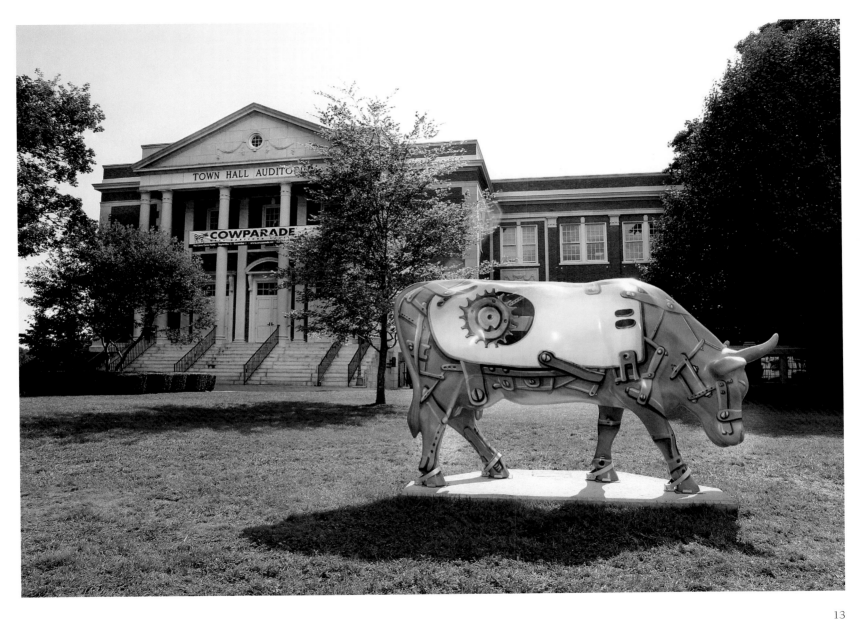

Guida's Milk & Ice Cream Herd

Guida's Milk & Ice Cream, presenting sponsor of CowParade West Hartford, is one of the largest independent dairies in New England. Since 1886 Guida's Milk and Ice Cream has had the reputation of supplying the finest products and service to its large customer base. Guida's sponsored a total of sixteen cows, including a replica of its mascot, SuperCow.

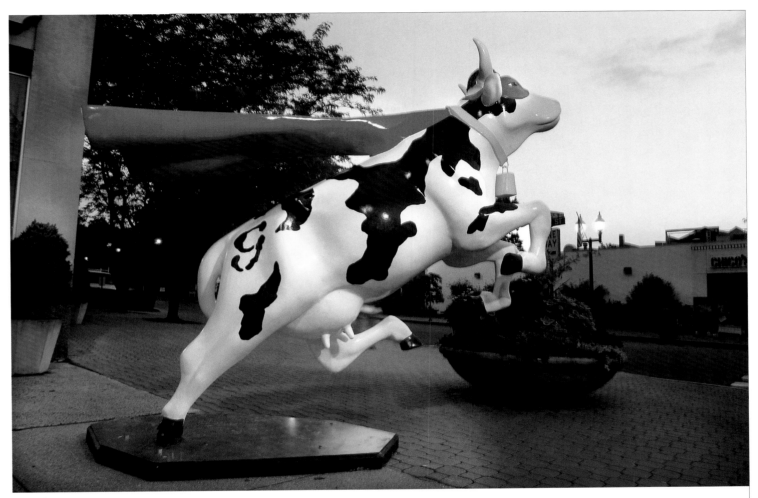

Guida's Super Cow
Scott Tao LaBossiere
Guida's Milk & Ice Cream

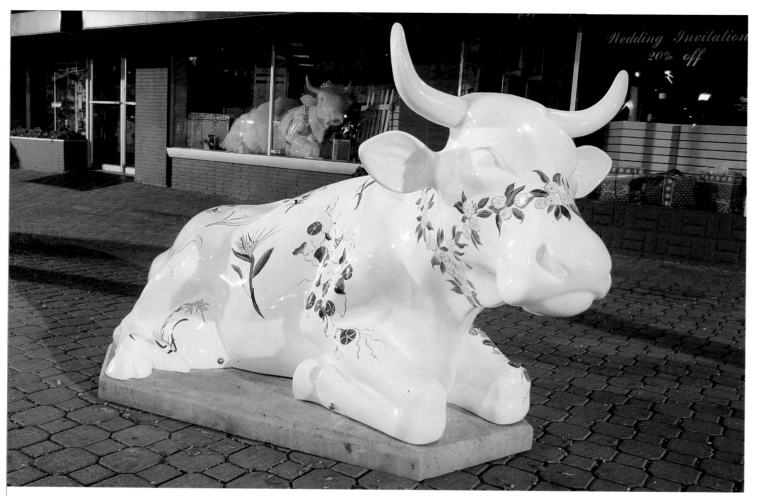

Meissen Cow
Wilson H. Faude, finish by Gengras Volvo/Dodge
Guida's Milk & Ice Cream

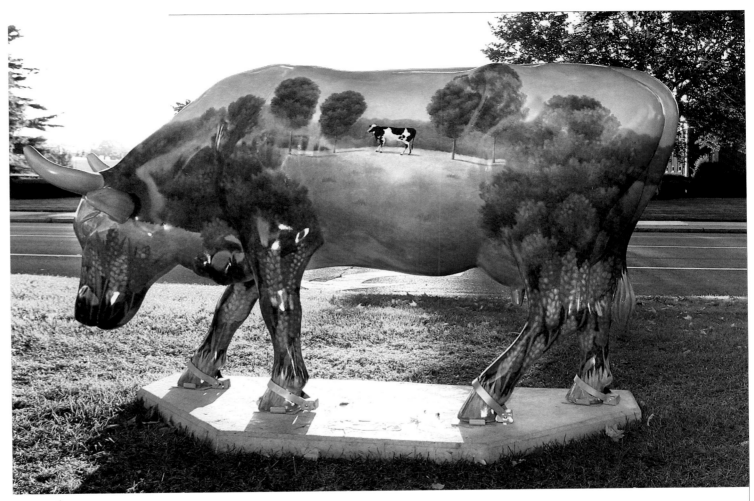

Pastoral Cow
Elisa Tenenbaum, Laura Meehan, Katharine Sofrin
Guida's Milk & Ice Cream

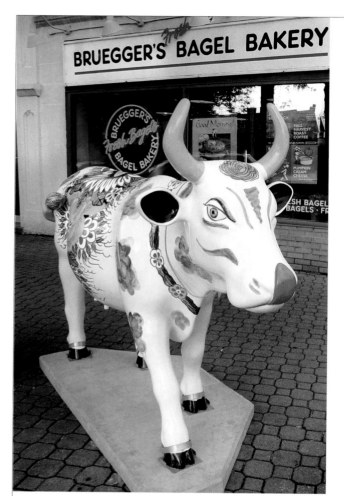

Delft Portrait Cow
Jane Keller Herzig
Guida's Milk & Ice Cream

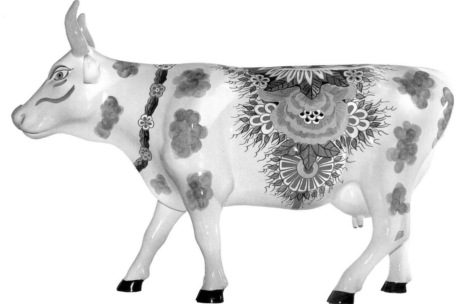

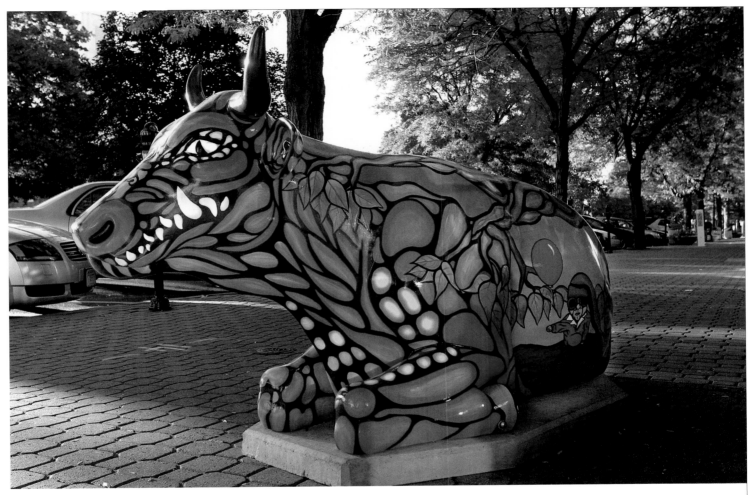

Bovinity
Joseph A. Dinunzio, Jr.
Guida's Milk & Ice Cream

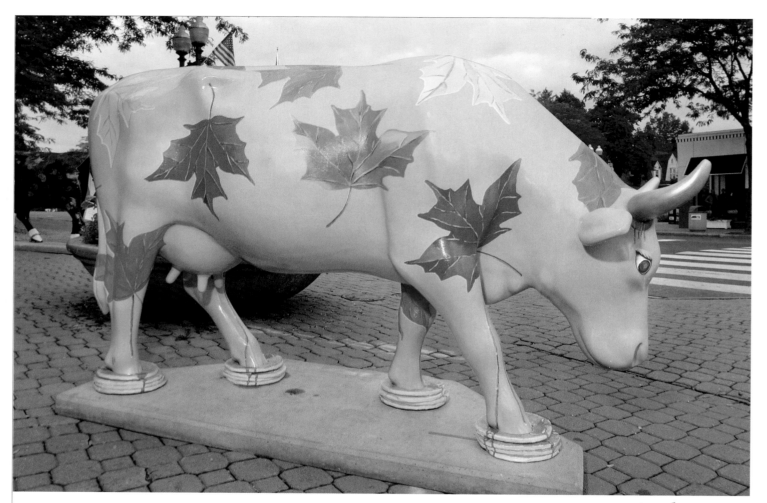

Maple Syrup Cow
Stephen, Gretchen, Rushton, and Hannah Brown
Guida's Milk & Ice Cream

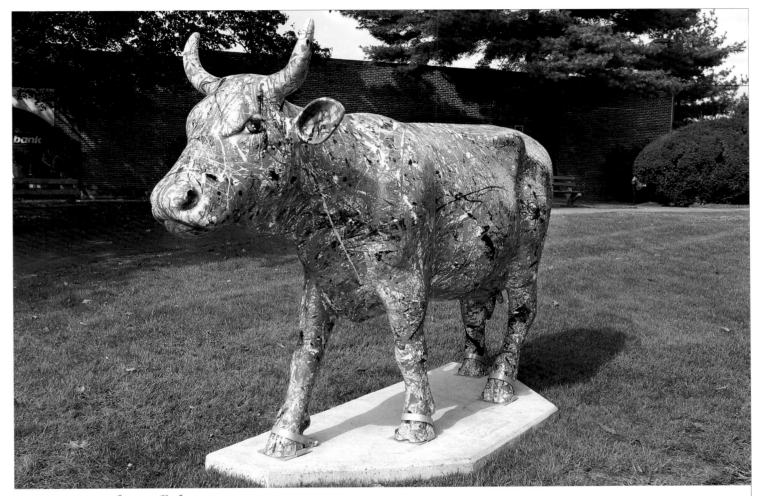

Mooove Over Jackson Pollock
ArtSparks & Adult Day Programs of HARC
Guida's Milk & Ice Cream

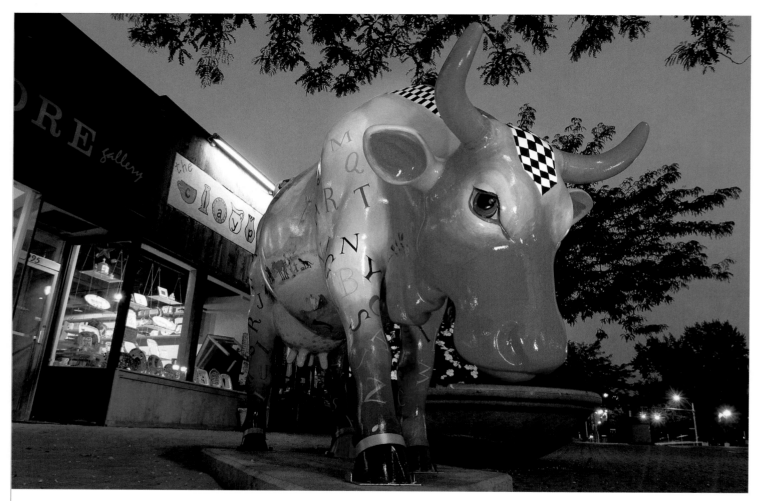

Left and Right:
Udderly Divine Bovine Rhymes
Sally Sargent Markey
Guida's Milk & Ice Cream

Left and Right:
Cow Barn
Mary Beth Whalen
Guida's Milk & Ice Cream

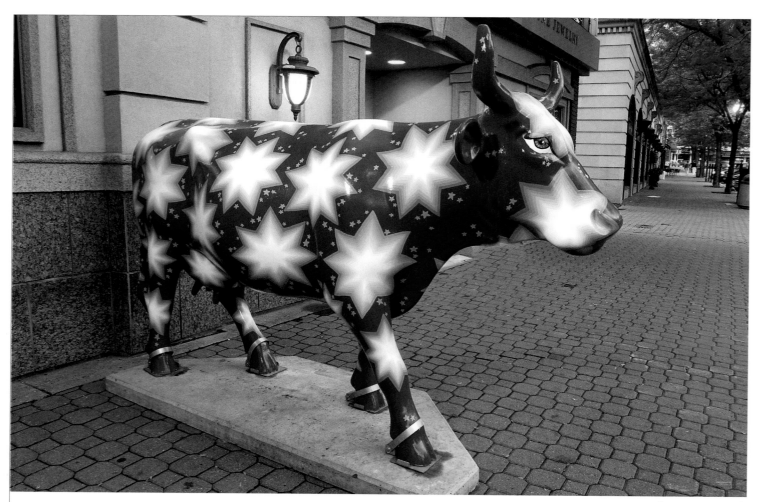

Star Light, Cow Bright
Bonnie Ouellette—Seven Hawks Studio
Guida's Milk & Ice Cream

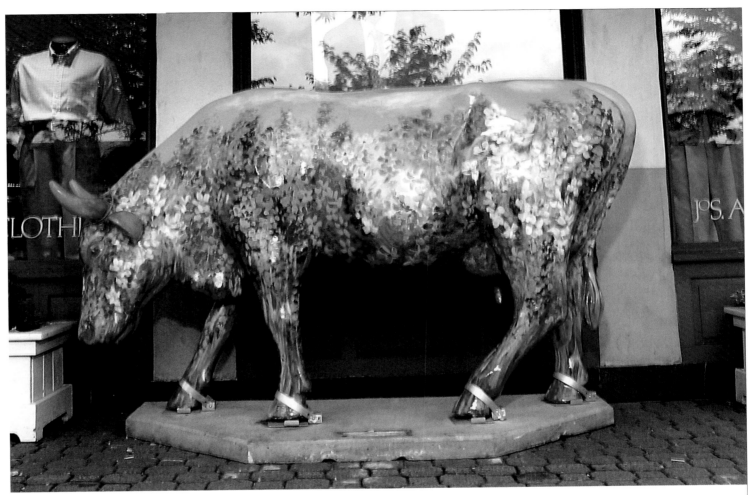

Garden Cow
Rea Nurmi
Guida's Milk & Ice Cream

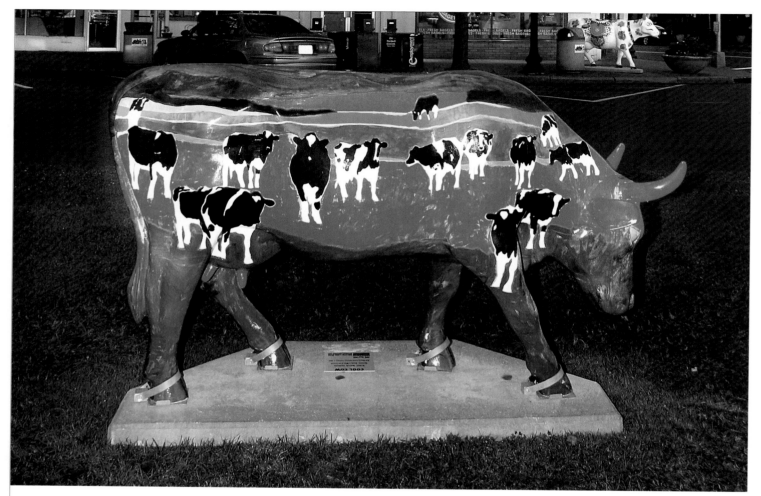

Cool Cow
Woody Jackson
Guida's Milk & Ice Cream

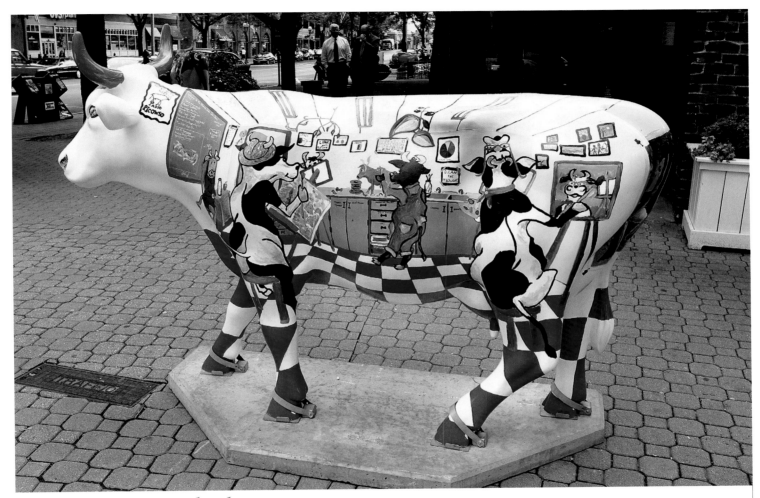

Art EDU-COW-TION Through History
Cindy Parsons and Connecticut Art Education Association
Guida's Milk & Ice Cream

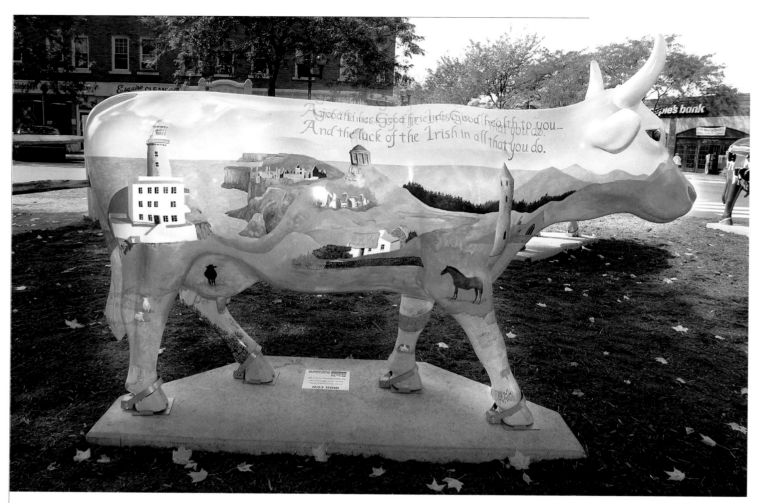

Left and Right:
Irish Cow
Terry Donsen Feder
Guida's Milk & Ice Cream

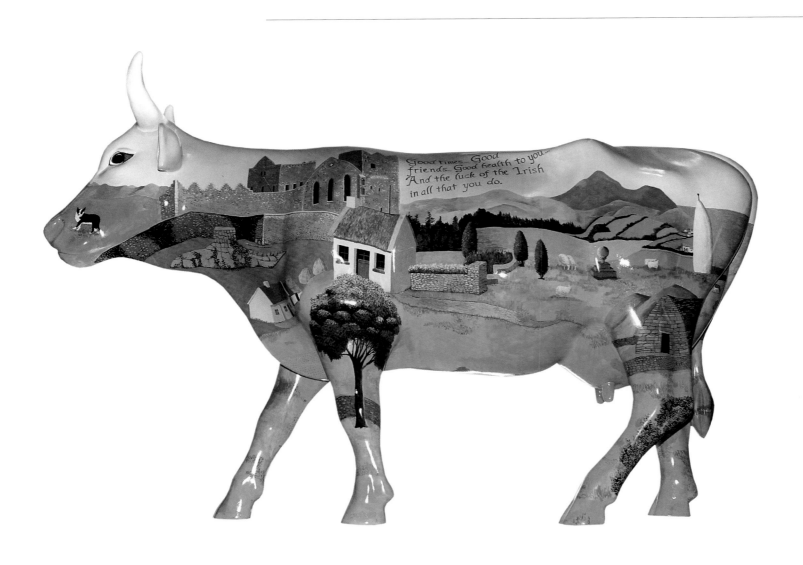

Good times. Good friends. Good health to you... And the luck of the Irish in all that you do.

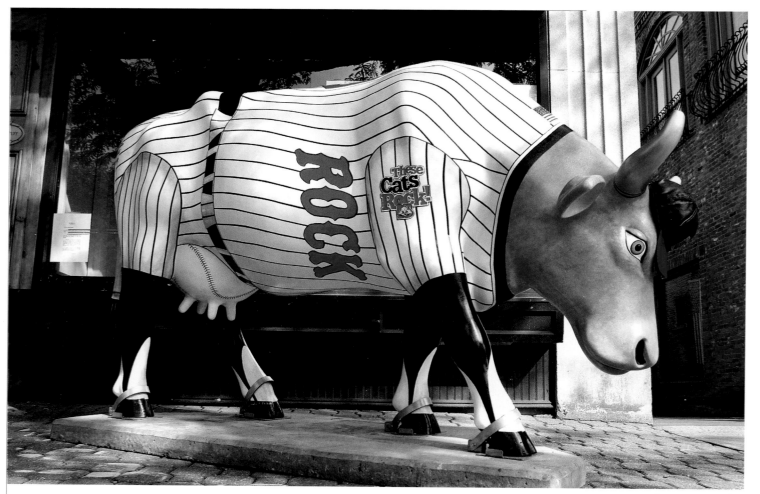

Moo Britain Rock Cats Baseball
Clinton A. Deckert
Guida's Milk & Ice Cream

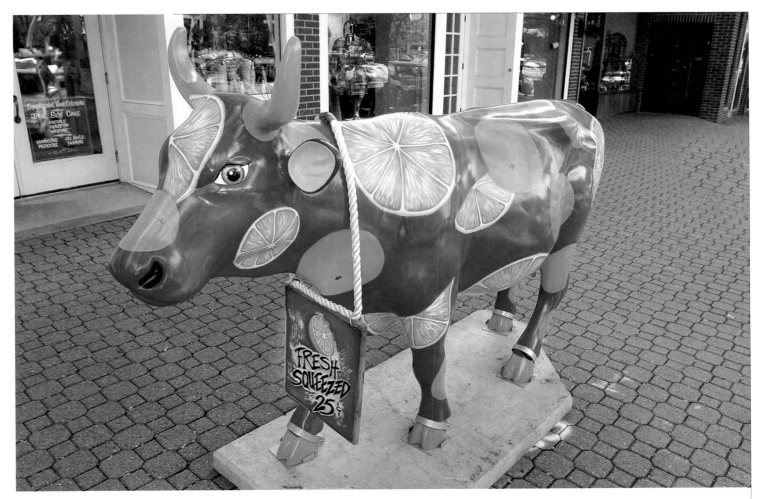

Moo Juice
Paula Tamborra-Berglund
Guida's Milk & Ice Cream

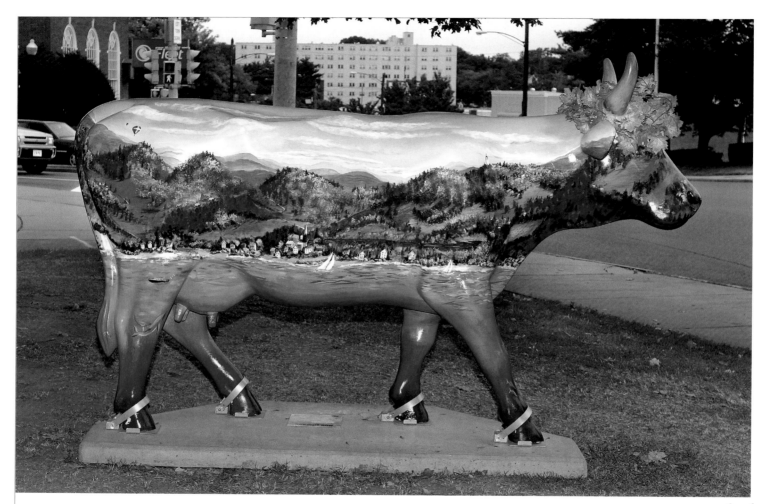

Moo England
Kelly Smurthwaite
Ginsburg Development Companies

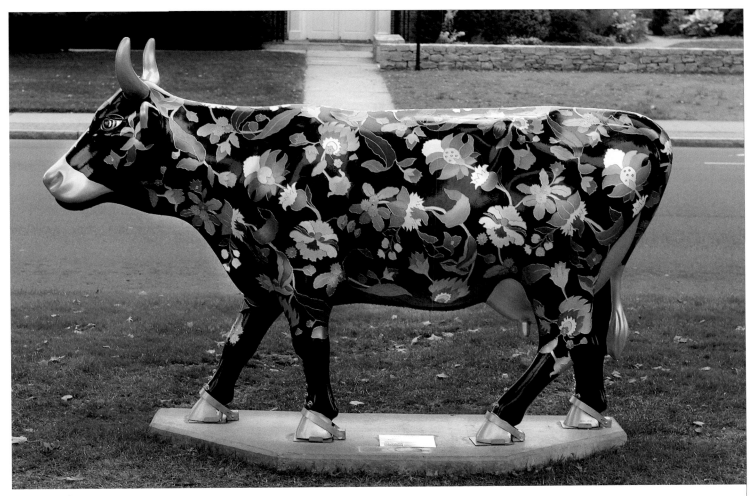

Cowsonne'
Jane Lowerre
Ginsburg Development Companies

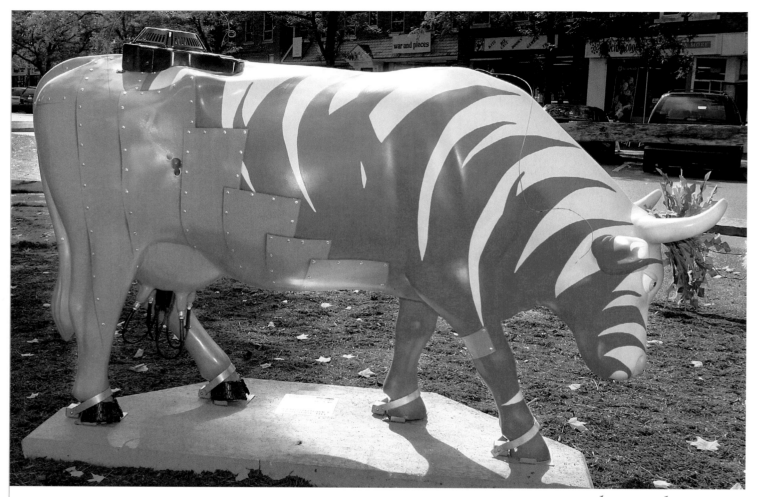

The Original Lawnmoower
John M. Murphy, Jr.
Allen Lawnmower, Inc.

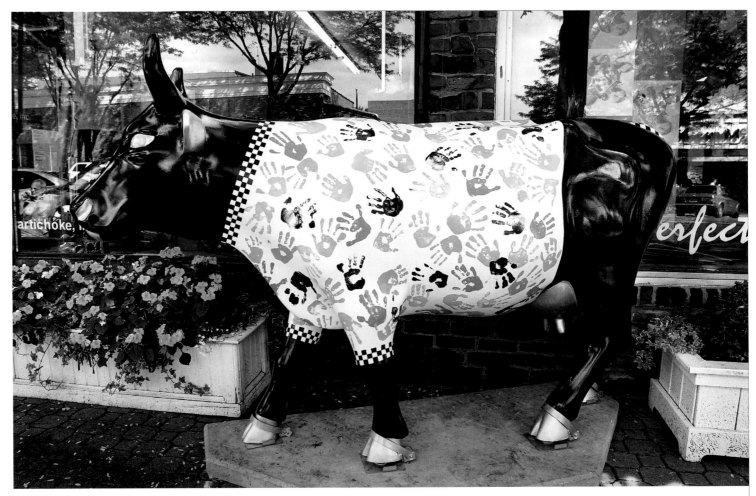

Peace Prints
Jean Mazo with Aiken School First Graders
Nail Perfection/Mandell Family Foundation & Data Mail/Greenfield Family &
Connecticut Packaging/Drs. Drew, Epstein, Fischman, Maltz, Rapoport and Wrubel

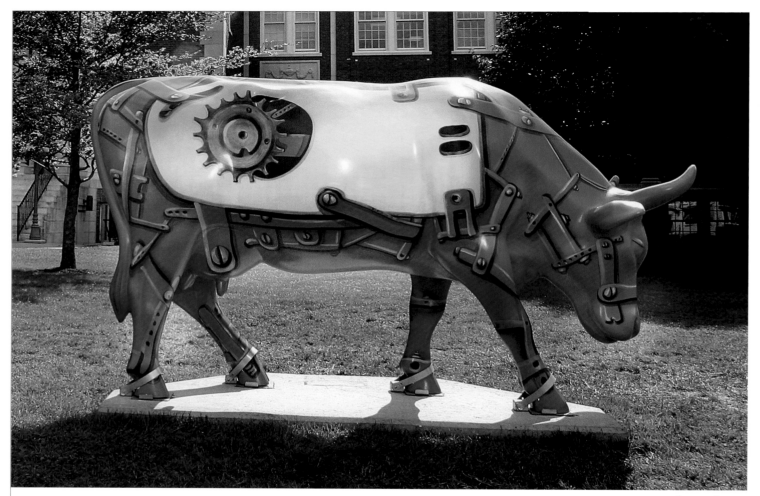

Mechanical Cow
Zora Janosova
Simons Real Estate Group LLC

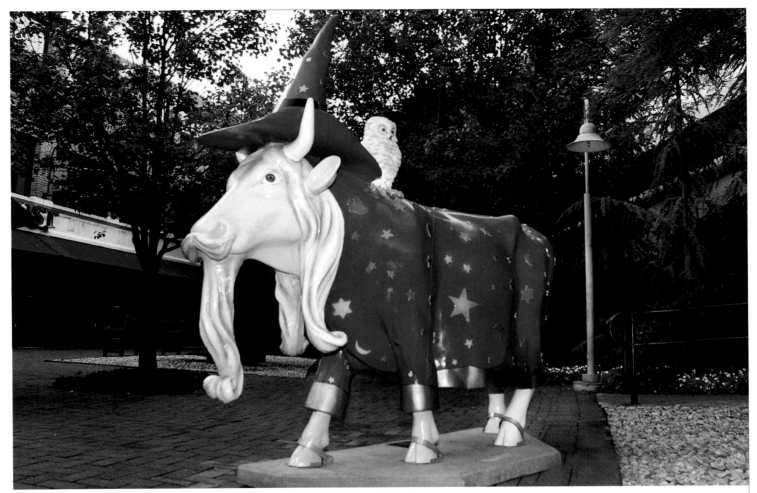

Wizard Cow
Juan Andreu
Simons Real Estate Group LLC

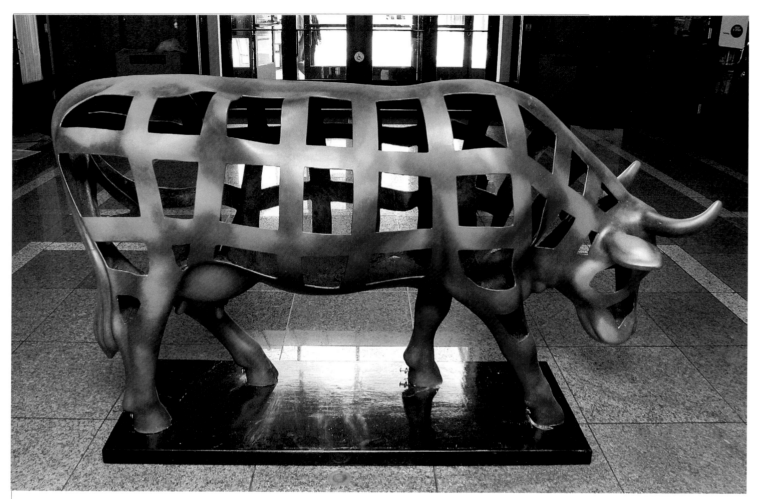

Vaca Sin Carne
Juan Andreu
Simons Real Estate Group LLC

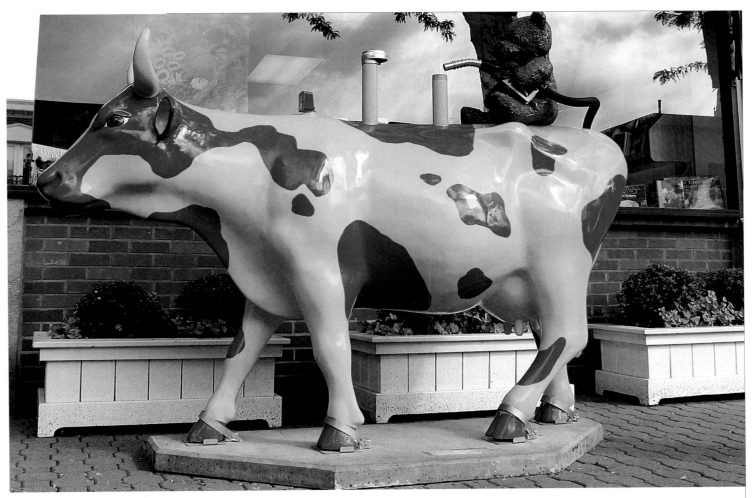

Miss Bessie Cow-Tankerous
Scott Tao LaBossiere
Tankworks/Teddy's Oil

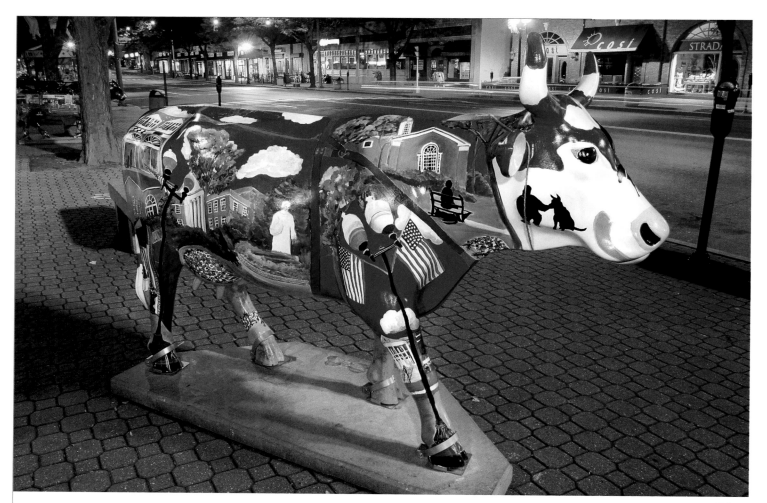

Fidelcow
Pat Beveridge
Fidelco Guide Dog Foundation, Inc.

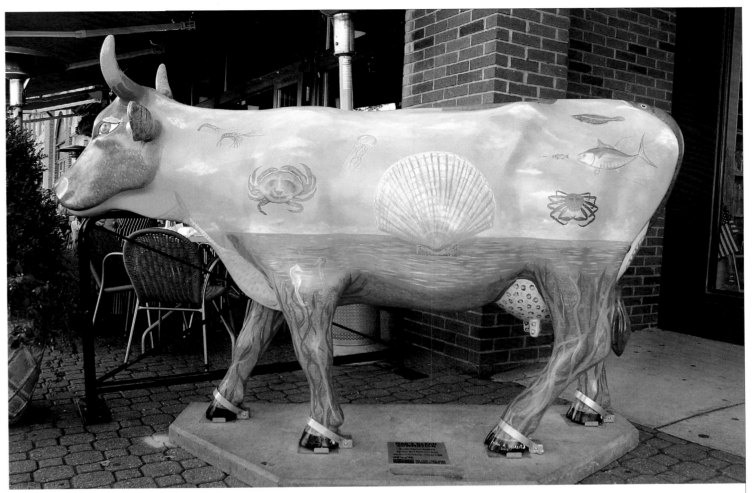

MAX's Ocean CowMotion
Clinton A. Deckert
MAX Restaurant Group

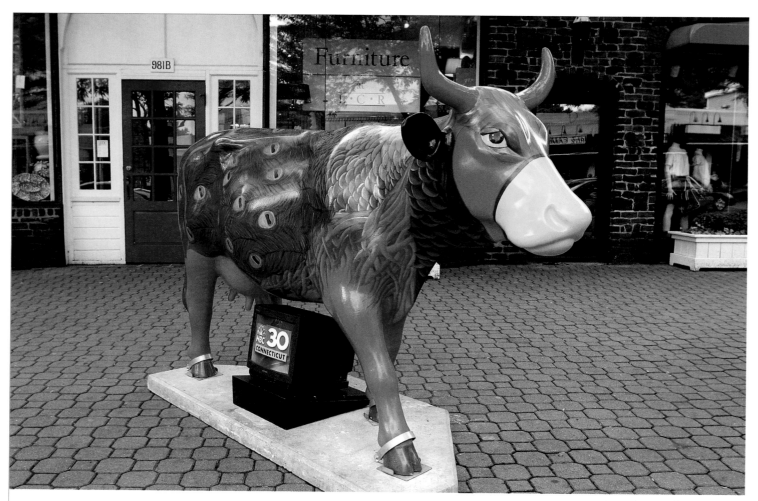

981B

Furniture

E·C·R

NBC 30 CONNECTICUT

National Broadcasting Cow
Eve Hadley
NBC30

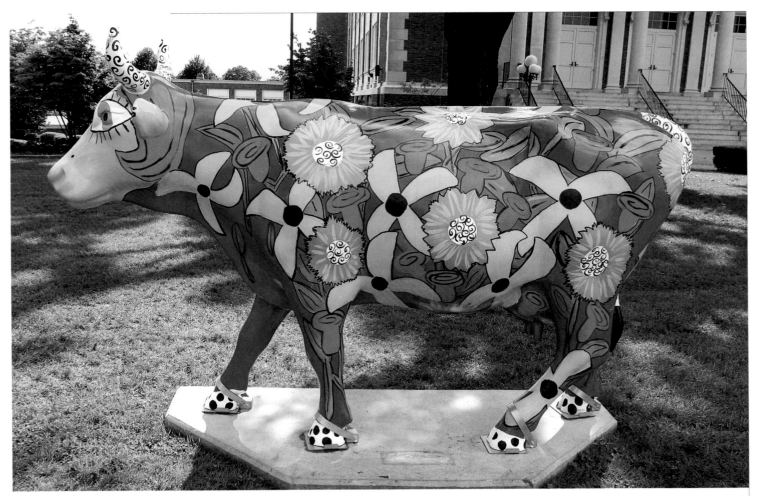

Spirited Cow
Jules Burt
Alan S. Goodman, Inc.

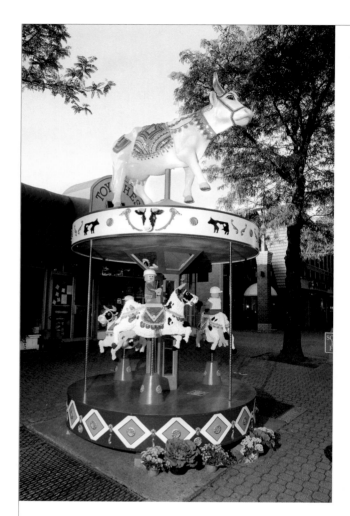

LEGO Cow-a-sel of Imagination
LEGO Model Builders, The Lego Company
LEGO Systems, Inc.

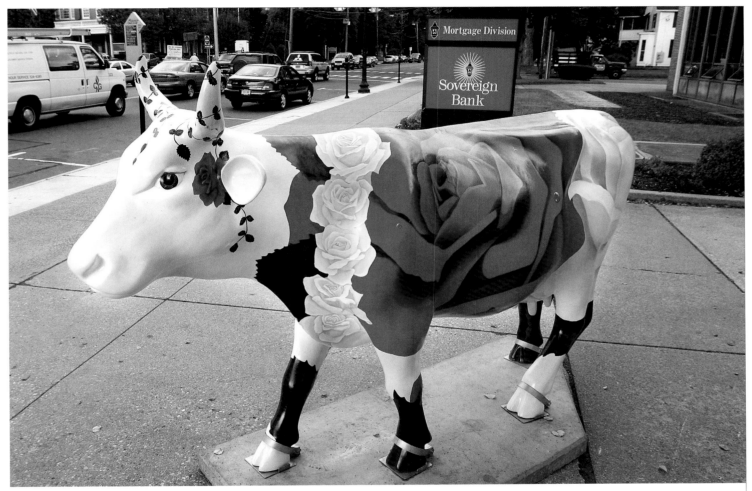

By Any Other Name . . .
Christa A. Elkovich
Sovereign Bank

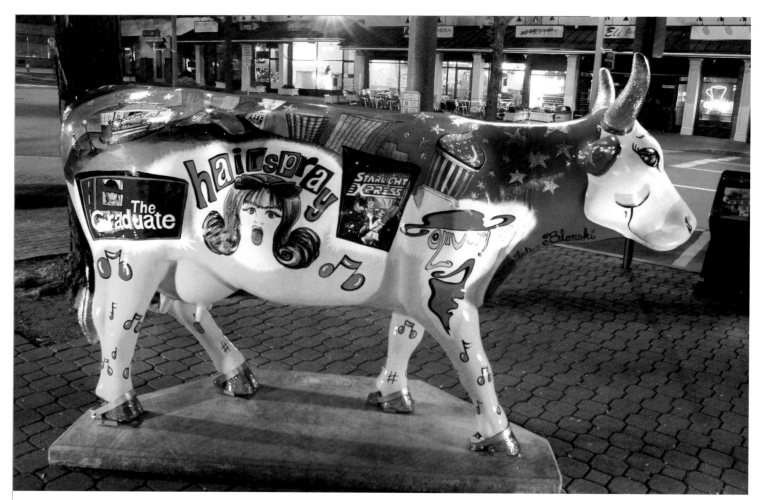

Udderly Broadway
Maribeth Blonski
Bushnell Center for Performing Arts

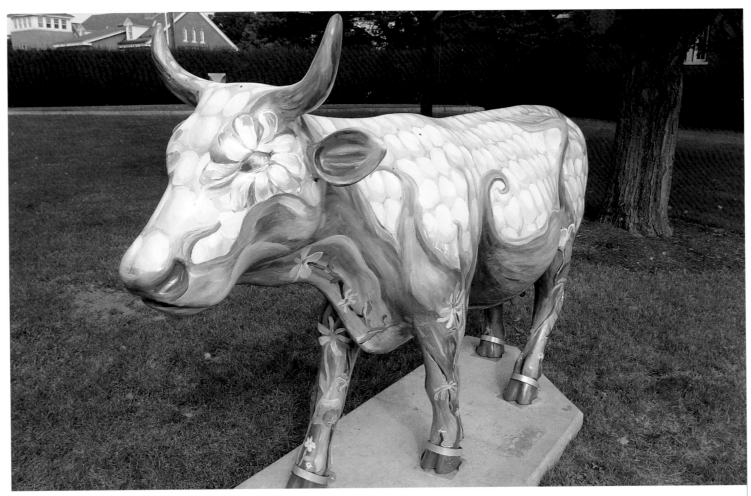

Corn on the Cow
Julie Pereira
Rosedale Farms, Moscarillo's Garden Shoppe,
Sandra Bourke & Prudential Connecticut Realty, and Anthem Blue Cross & Blue Shield

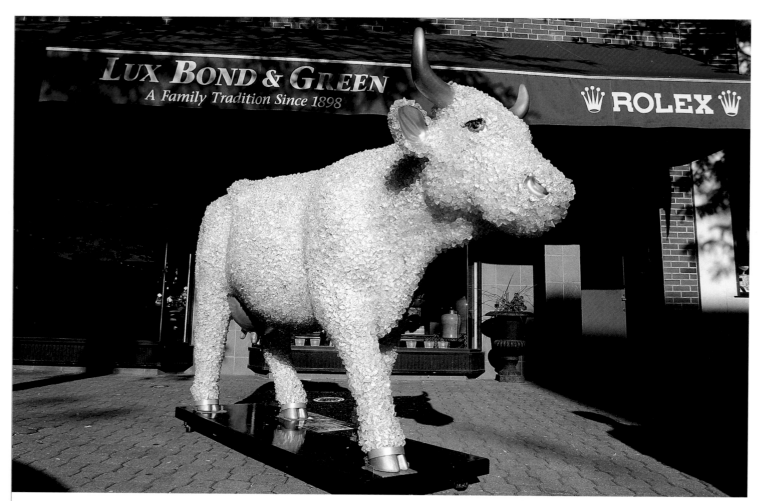

Diamonds Are For Heifer
Michail Shaw, Sheryl Green and Staff
Lux Bond & Green

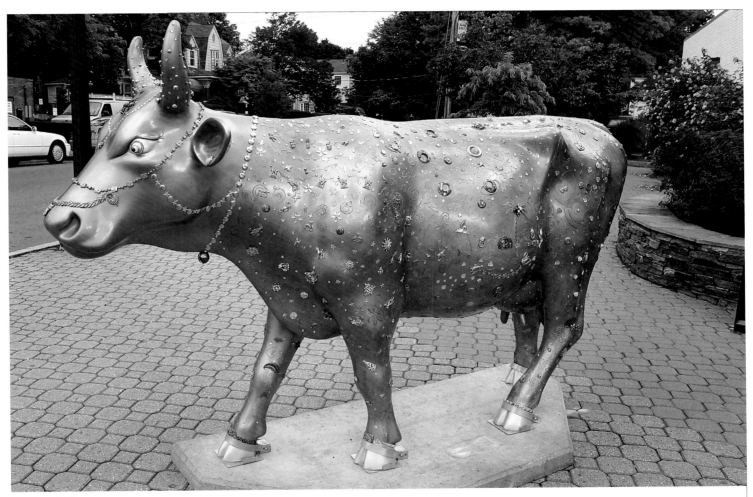

Bedazzled Bovine
Lori Catlin Garcia
Chubb & Son

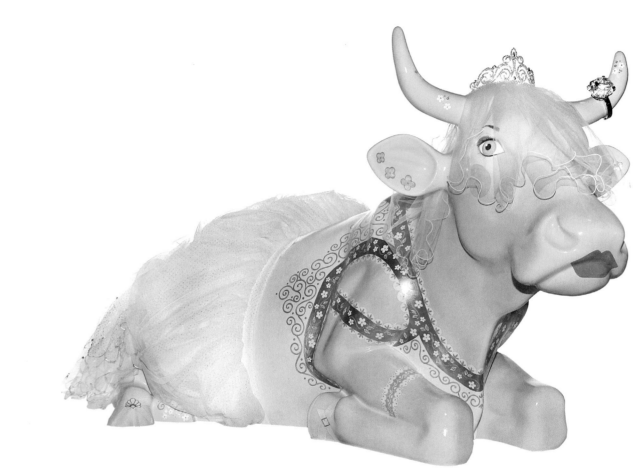

Moozel Tov
Pamela Weltman, Maria Sciucco
Jewish Ledger/NRG Connecticut LLC

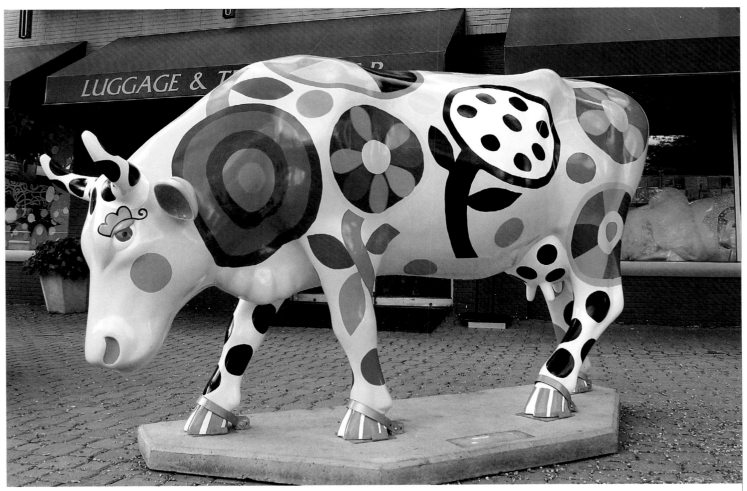

Udderly Exotic
Beth Levey
Plimpton's Stationers, Esquire Cleaners, and Robert Woodworth

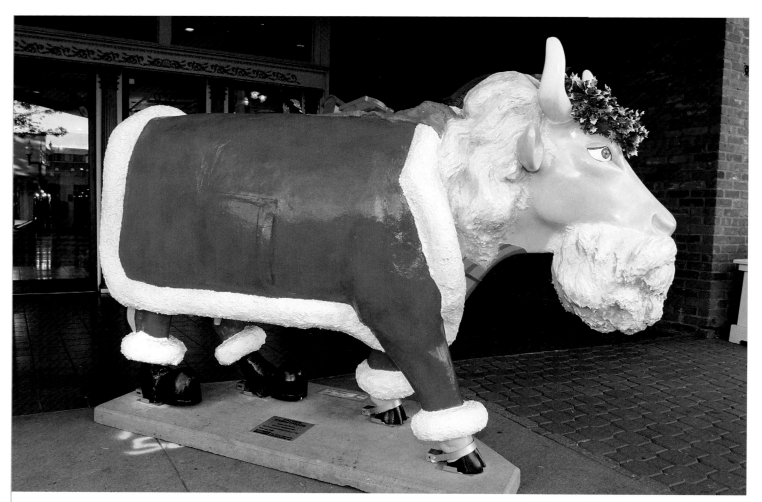

Left and Right:
Father Christmas
Juan Andreu
Westfarms

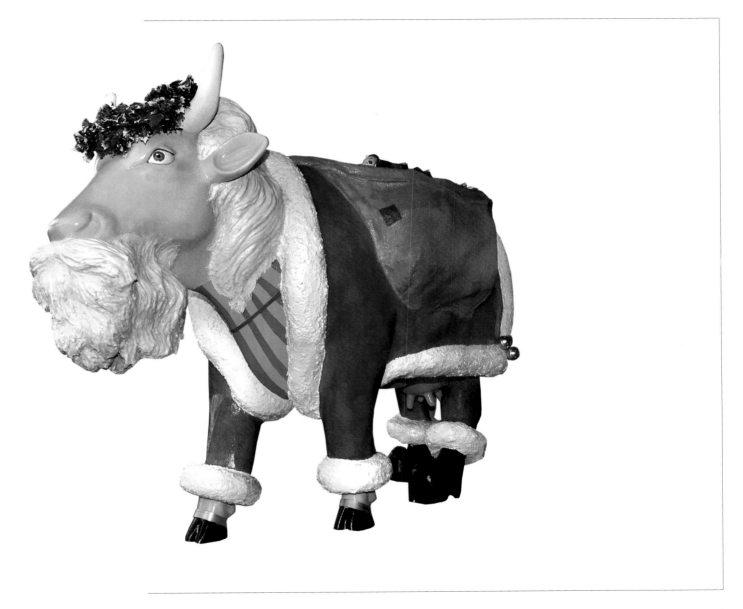

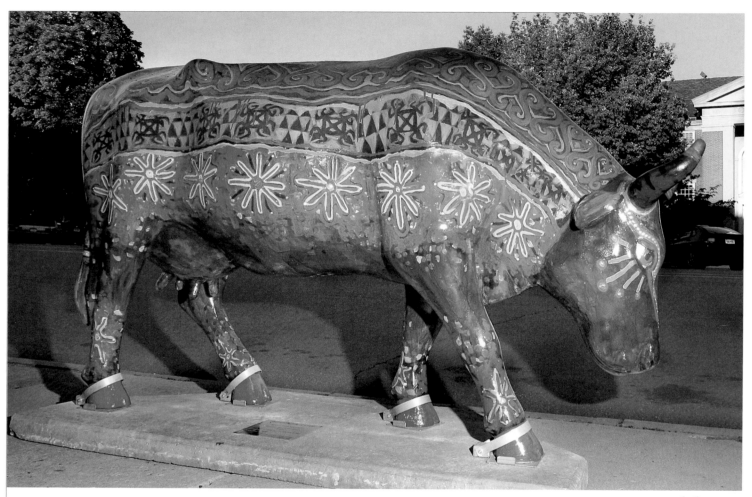

Adinkra Cow
Cora Marshall
Simons Real Estate Group LLC

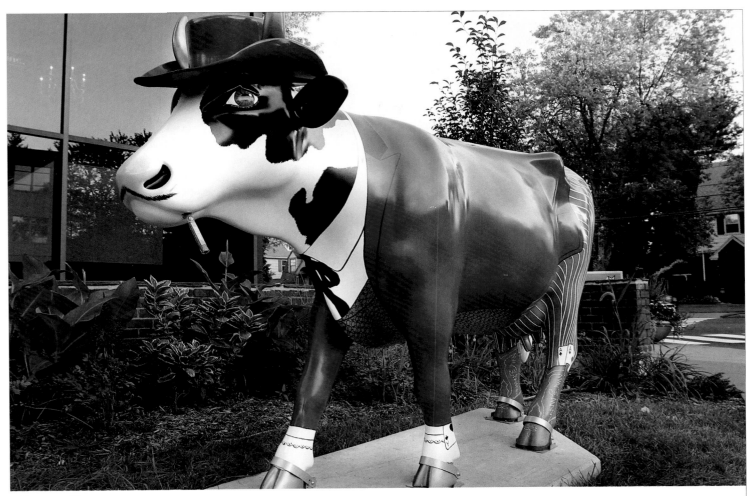

The Gambler
John Main and Jim Serverson
CowParade

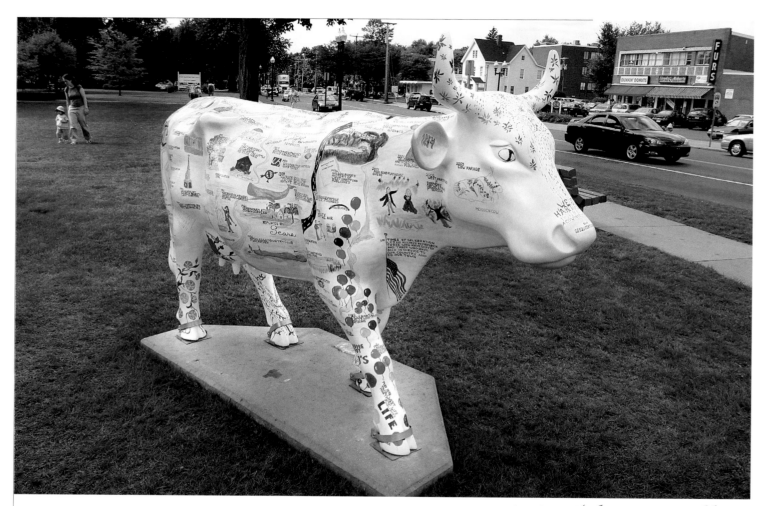

West Hartford—A Cow in Celebration
Wilson H. Faude
150 West Hartford Celebrates

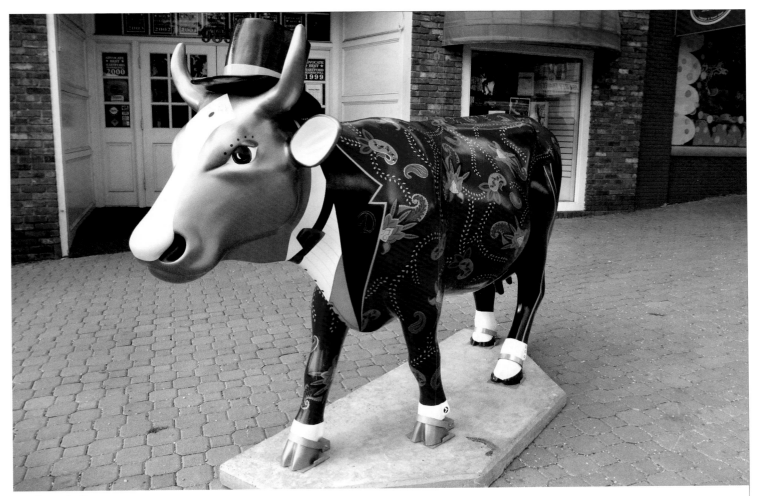

Fashionabull
Gayle Young
Daswani Clothiers

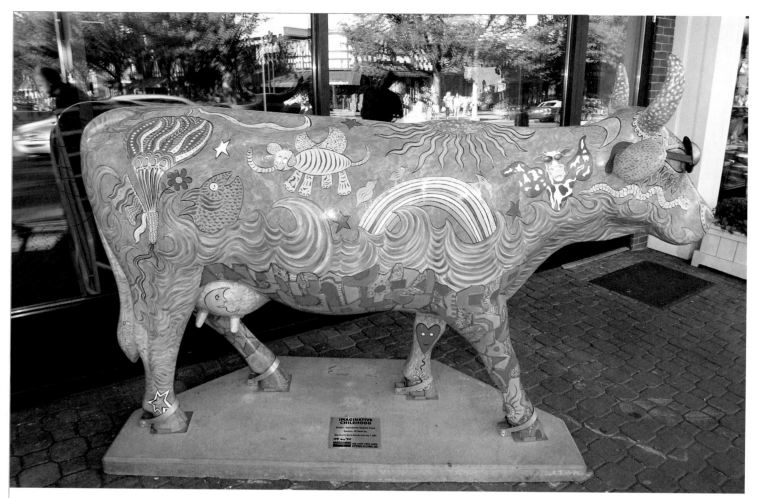

Imaginative ChildHOOD
Humberto Castro Cruz
HP Hood Inc.

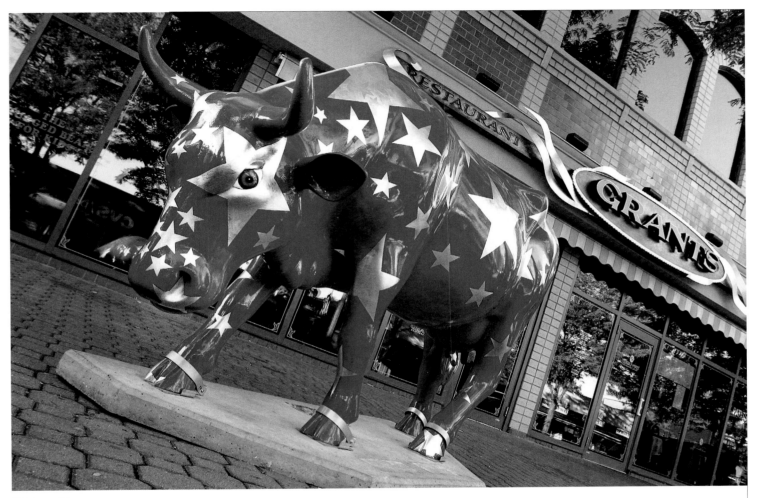

Rising Star
Lauren Serven
BlumShapiro and HartfordMetro Alliance

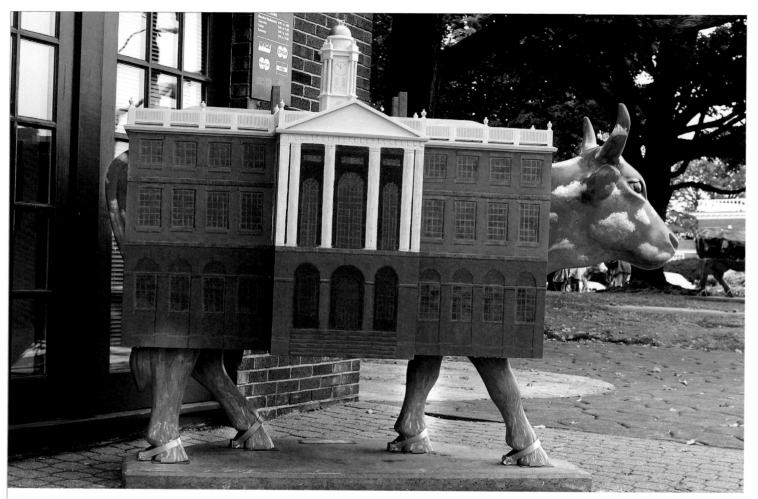

Left and Right:
Old State Cowse
Gigi Horr Liverant and Peter Arkell
People's Bank

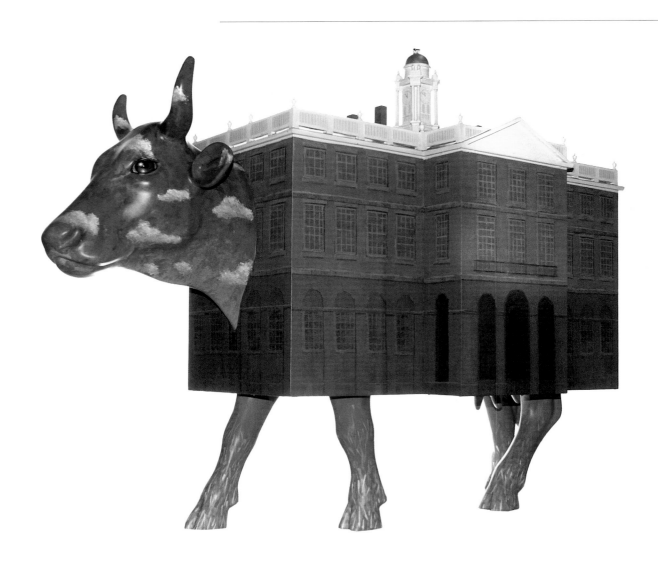

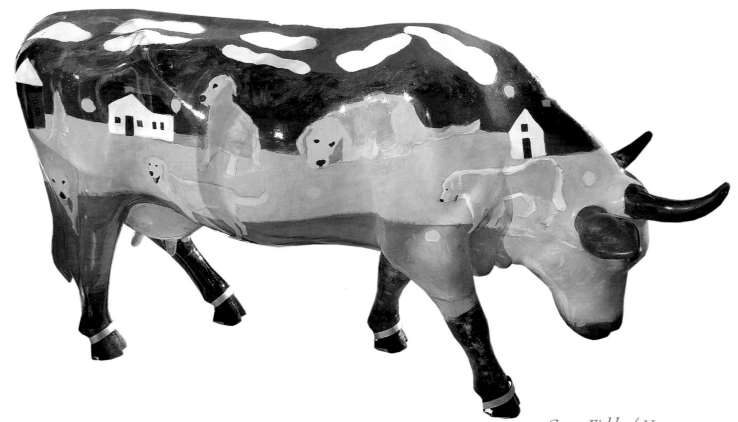

Green Fields of Home
Woody Jackson
Coldwell Banker Residential Brokerage

ctnowcow
Debra Conant
ctnow.com/Hartford Courant

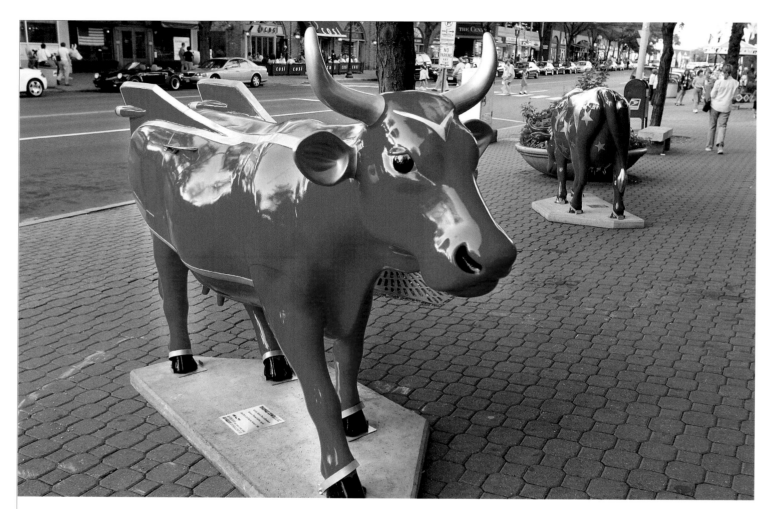

Left and Right:
Thomas Cowdillac
Scott Tao LaBossiere
Thomas Cadillac Jaguar

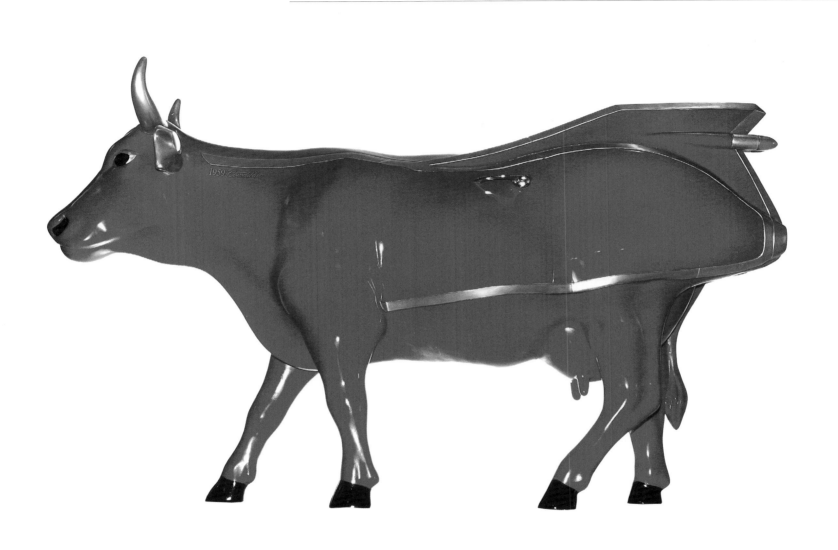

Field Goals
Terry Donsen Feder
New England Financial/Gent Financial Group LLC

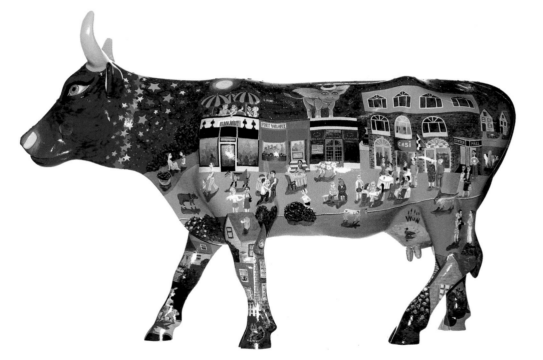

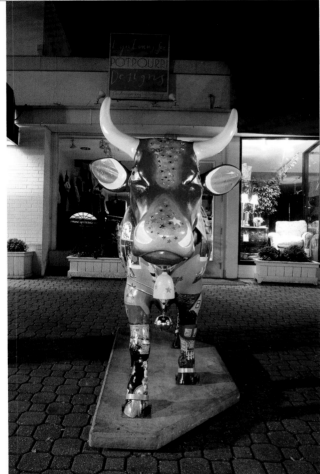

Moogic Cow
Natasha Sazonova
971-975 Farmington Avenue: E.L. Wilde, La Perla Fine Jewelers, Lyn Evans Potpourri Designs, The Toy Chest, Andrews Ltd Partnership

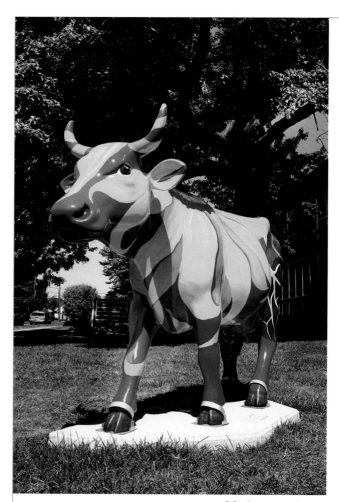

Udderly SunFlowers
Jodi Mendlinger
Filomeno & Company P.C.

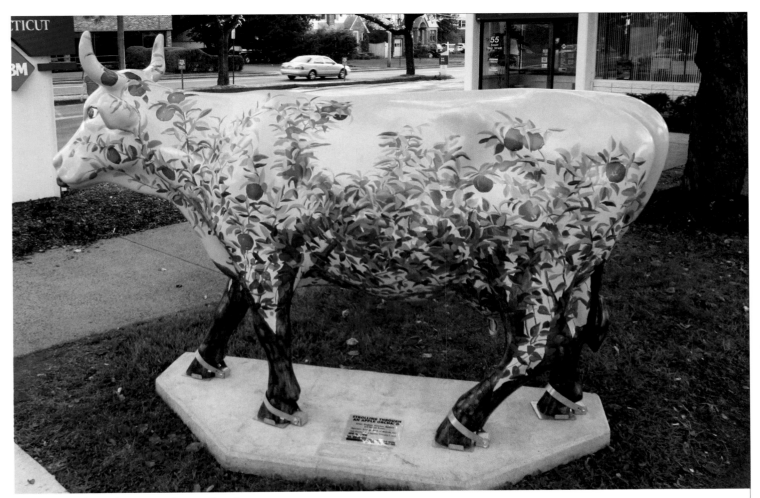

Strolling Through an Apple Orchard
Stephen, Gretchen, Rushton, and Hannah Brown
Savings Bank of Manchester

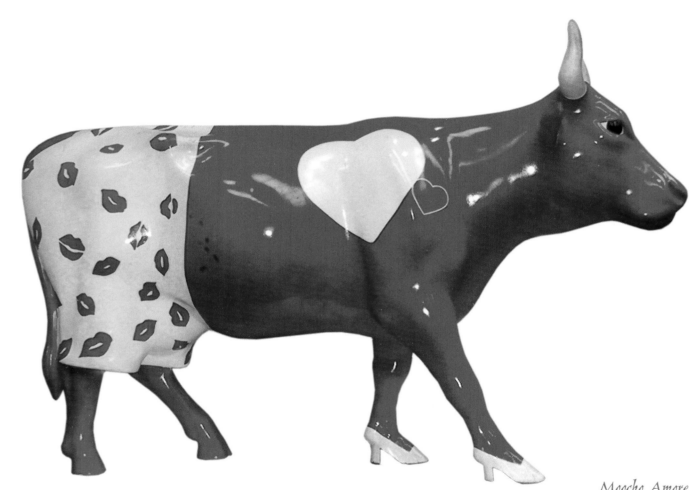

Moocho Amore
Scott Tao LaBossiere
All Waste, Inc.

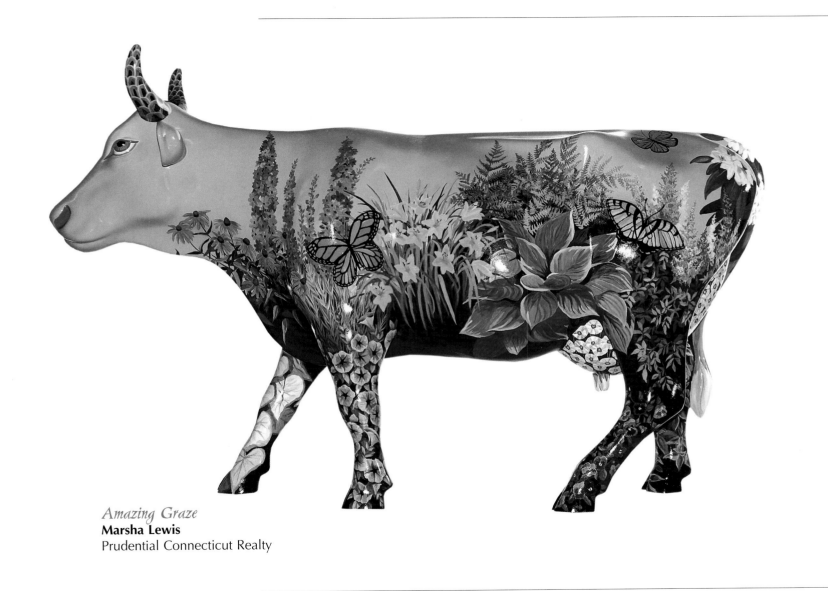

Amazing Graze
Marsha Lewis
Prudential Connecticut Realty

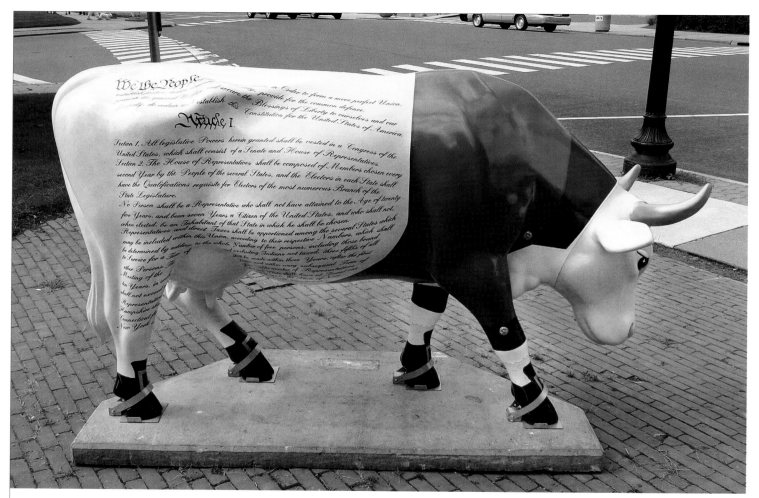

The COWnstitution State
Margot Davis Sappern
CT Lottery

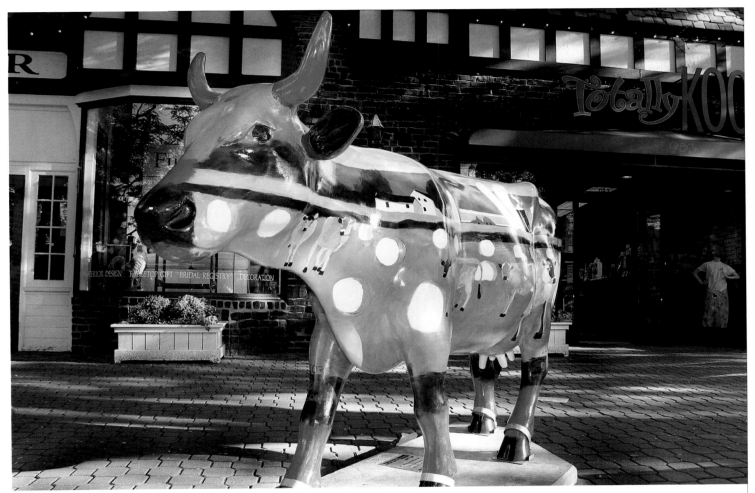

Cheddar Cow
Woody Jackson
Cabot Creamery

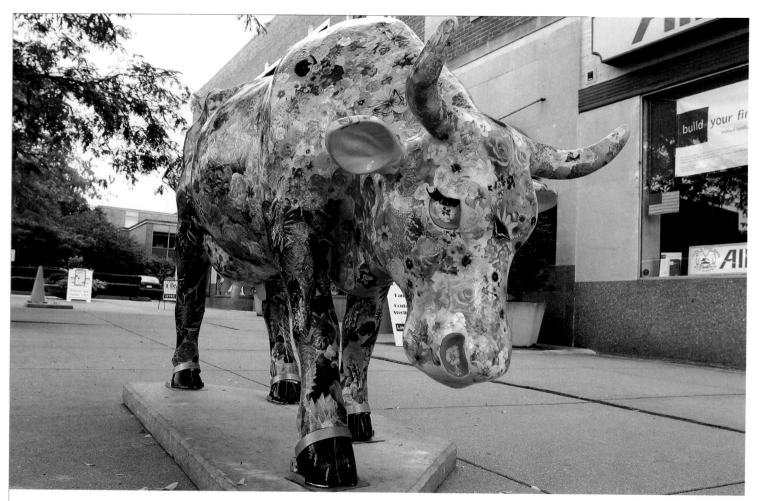

It's a Bloomin' Cow!
Sandy Welch and Residents
Village at Buckland Court

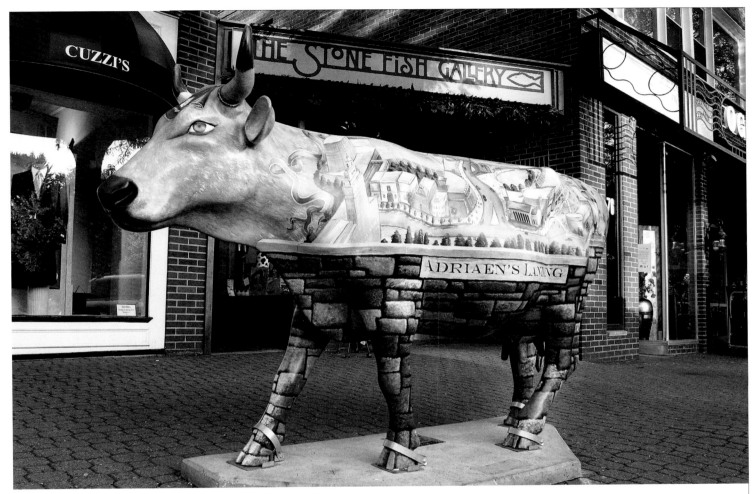

Vintage Adriaen's Landing Cow
Nancy Kramer and Michael Kramer
Hartford Magazine

Daisy's Dream
Randy Gilman
CowParade & Finlay Printing

A Study in Still Life
MacKenzie-Childs
CowParade

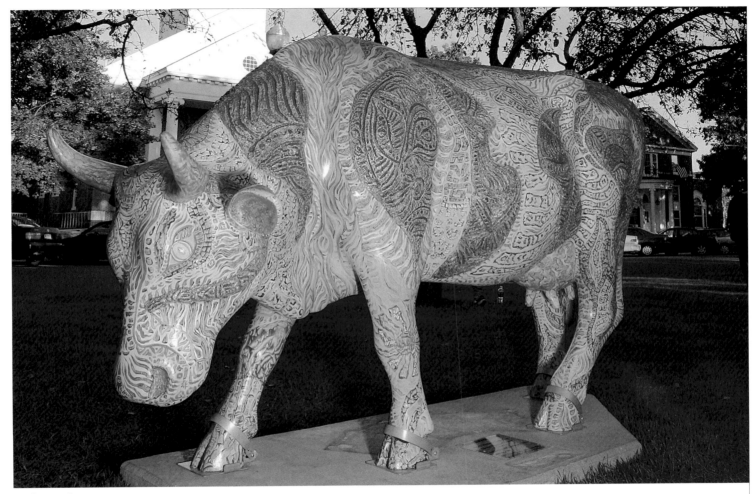

Cobreazul Cow
Humberto Castro Cruz
Ginsburg Development Companies

Chicago, Illinois 1999

CowParade (aka Cows on Parade) was, according to Mayor Richard Daley, "The single largest and most successful event in the history of Chicago." City officials in Chicago estimated that the event drew 2 million tourists and added $200 million to the local economy from tourism alone. Oprah Winfrey fell in love with the cows, featuring the event on her show by bringing an entire herd into her studio. She followed up at the auction by purchasing three of the precious bovines. Chi-cow-go's 300 cows were concentrated mostly along Michigan Avenue, the Loop, River North and the new Museum Campus, but were spotted throughout the city in surprising and unique locations.

Chi-cow-go
Nancy Parkinson Albrect
Central Michigan Avenue Association

Udderly Chic (k)
Craig Wartman, Robert Finzel
Museum of Science and Industry

DoubleMoo
Peter Van Viet, Lou Beres & Associates
Wm. Wrigley Jr. Company

Moooonwalk
Craig Wartman, Robert Finzel
Museum of Science and Industry

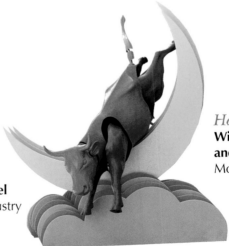

Hey-Diddle-Diddle
**William McBride with Pat Moss
and Michael Stack**
McBride & Kelley Architects

New York, New York 2000

Featured in the *USA Today*, *New York Times*, CNN, and *NBC's Today Show*, CowParade gained international attention in the summer of 2000 with the introduction of some 400 plus cows on the streets of New York City. CowParade was the first and remains the only art event to take place in all five New York City boroughs simultaneously. The cows were set out to pasture in all the top spots of the city including Bryant, Battery and Central parks, Rockefeller Center, Park Avenue, South Street Seaport, and Grand Central Station. An estimated 25 million people from around the globe saw the Cows! Participating artists included Peter Max, Leroy Neiman, Red Grooms, Romero Britto and James Rizzi, among other world-renowned artists. Satellite events were staged in nearby Stamford, Connecticut (60 Cows) and West Orange, New Jersey (27 Cows).

Four Alarm Cow
Red Grooms
American Craft Museum

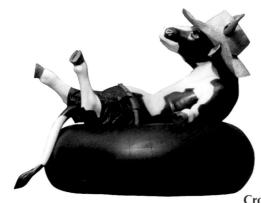

Fresco
Crocket Effects
J. Crew

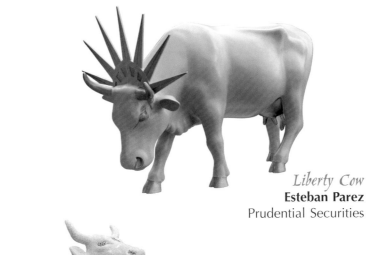

Liberty Cow
Esteban Parez
Prudential Securities

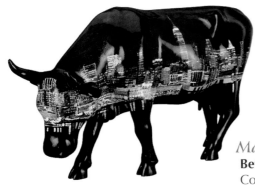

Moo York Riv Moo
Betty Tomkins
CowParade

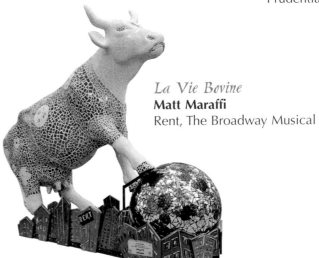

La Vie Bovine
Matt Maraffi
Rent, The Broadway Musical

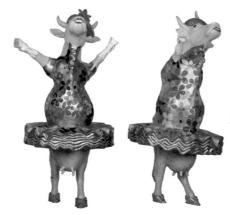

Frida Stare and Ginger Rodgers
Linda Dolack
Stuart Weitzman

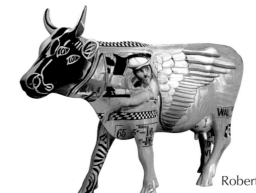

Now Cow 2000
Paul Giovanopolous
Robert and Barbara Wagner

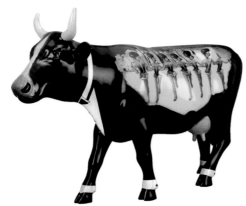

Radio Moosic Hall
Patricia Miner-Sutherland
Emigrant Savings Bank

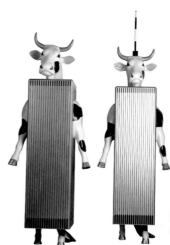

The Twin Cowers
Silk Fish Design, Inc.
Oppenheimer Funds, Inc.

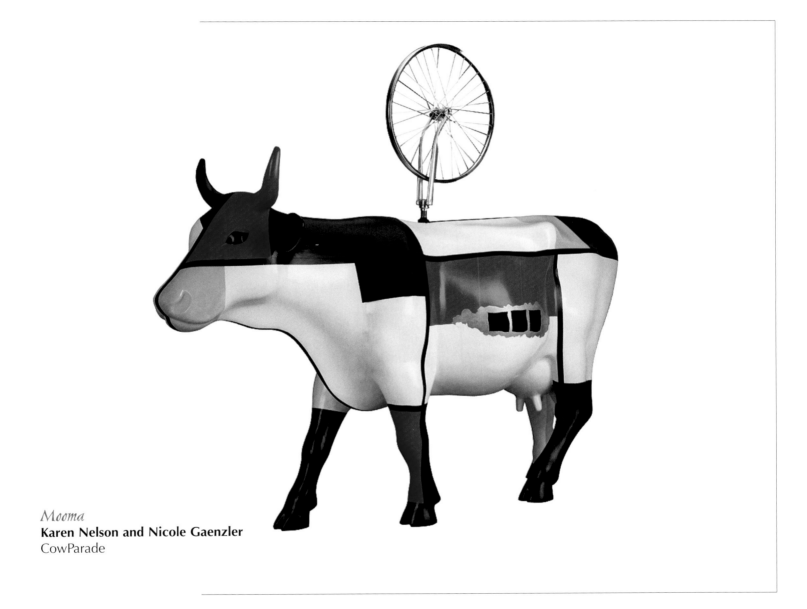

Mooma
Karen Nelson and Nicole Gaenzler
CowParade

Kansas City, Missouri 2001

CowParade headed back to the Midwest in the summer of 2001 to Kansas City, Missouri, one of the oldest cow towns. Ever since the first Texas longhorns arrived in 1846, cows and Kansas City have been inextricably bound, and CowParade Kansas City was a celebration of that history and jazz music. 200 newly minted cows grazed in both Kansas City, Missouri and Kansas City, Kansas in various herd locations, including Country Club Plaza, Crown Center, Union Center Barney Allis Plaza and Swope Park.

Going to Kansas City
Cynthia Hudson
The Kansas City Star

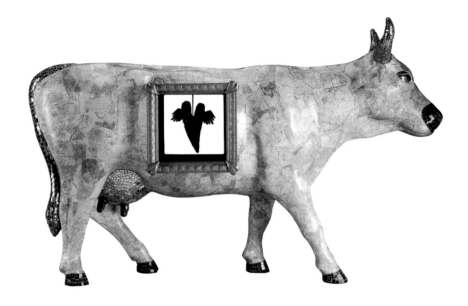

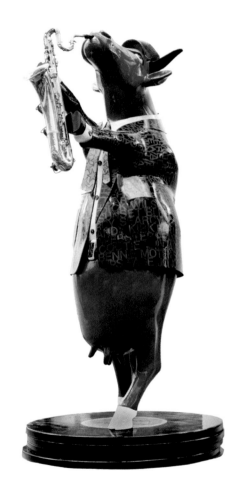

Top:
The Art of Americow
Eclectics: An Artists' Cooperative
The Country Club Plaza

Right:
Charlie Parcow
Harv Gariety, Hallmark Design Photography
Crown Center

Houston, Texas 2001

CowParade Houston was simply over the top. 300 plus new bovine creations blanketed the greater Houston area to the delight of the area's 4 million residents and countless visitors. From works such as *Texas Moobonnets, Texas Landscape, Texas Historic Cow*, and Mooooving *Flag of Texas*, Houston's and Texas' rich and 'udderly' wild history was a predominant theme. The exhibition, which ran from September 1 to December 15, 2001, was spearheaded by and benefited the world renowned Texas Children's Hospital, which netted over $1 million from the event and auction. *Mooonwalker*, one of CowParade's tallest creations, can be found on permanent display at George Bush International Airport in Houston.

Deep in the Art of Texas
Elizabeth F. Hornik
Jackson Walker L.L.P.

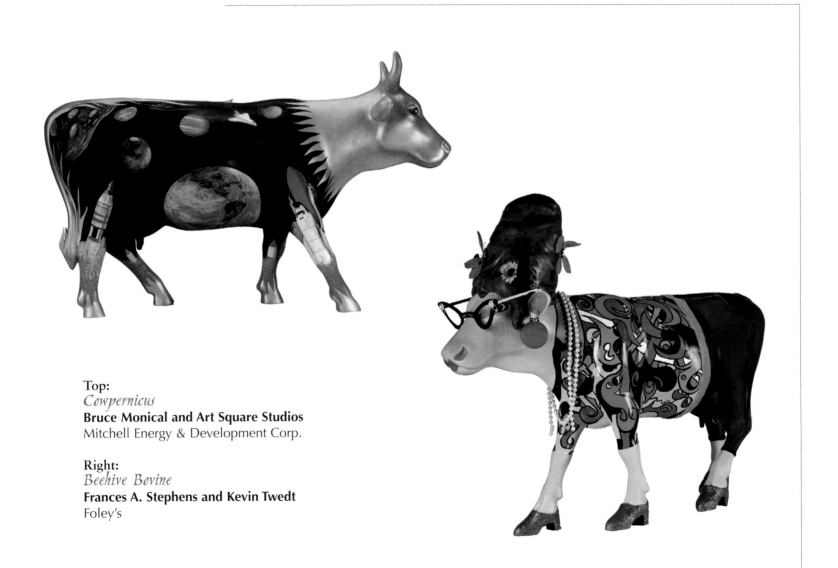

Top:
Cowpernicus
Bruce Monical and Art Square Studios
Mitchell Energy & Development Corp.

Right:
Beehive Bovine
Frances A. Stephens and Kevin Twedt
Foley's

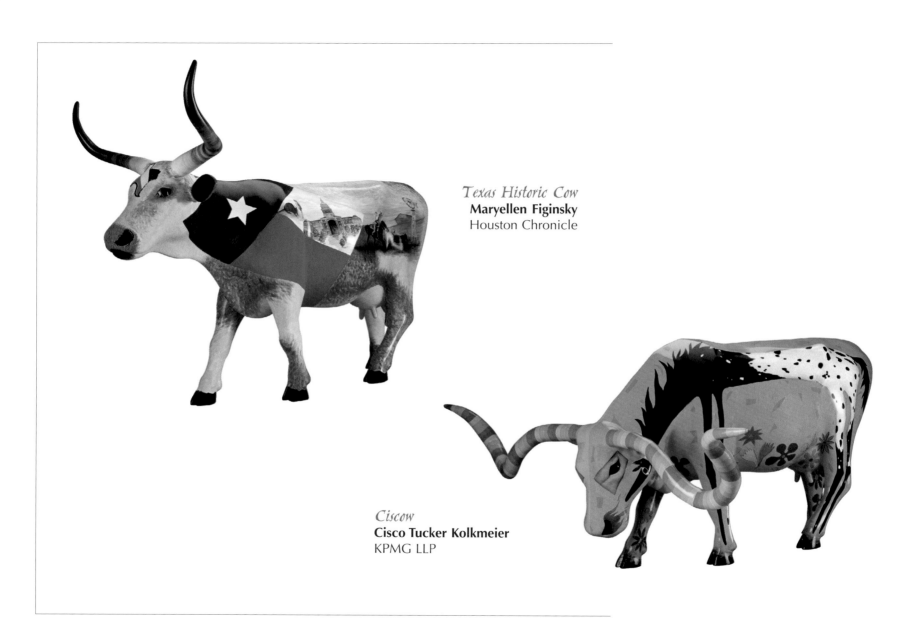

Texas Historic Cow
Maryellen Figinsky
Houston Chronicle

Ciscow
Cisco Tucker Kolkmeier
KPMG LLP

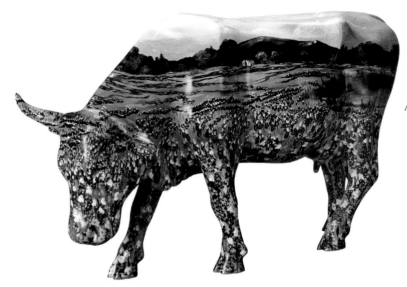

Texas Moobonnets
Kimberly Kooser Keefe
American Shooting Centers

Texas Landscape
Earl Staley
Downing Street, Sterling Bank, Taco Milagro

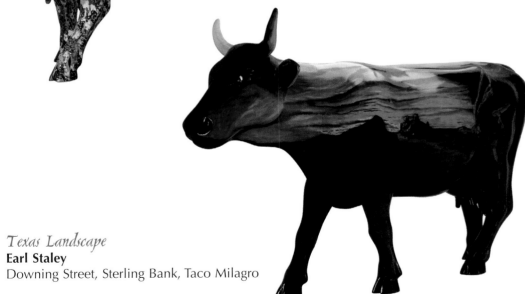

London, England 2002

CowParade London 2002 took many twists and turns. Originally scheduled for the summer of 2001, the event was postponed due to the onset of the foot-and-mouth epidemic. Finally, after two years in the making, 150 cows finally were set out to graze the streets and sidewalks and in the parks of London. Buckingham Palace, Trafalgar Square, the Royal Exchange, Canary Wharf, and the London Underground were all home to the Cows. Sotheby's hosted the live auction at the conclusion of the event drawing a CowParade and Sotheby's record crowd of 1500 people.

Beefeater—It Ain't Natural
Steve Finlay
CowParade London

Milk Ma(i)de
the DnAfactory
CowParade London

Madame LaVache Goes to Market
Terry Bell-Halliwell
CowParade London

City Cow
Pamela Howard
Lovells

Martha
Patrick Hughes
CowParade London

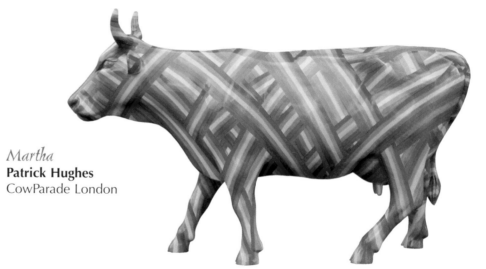

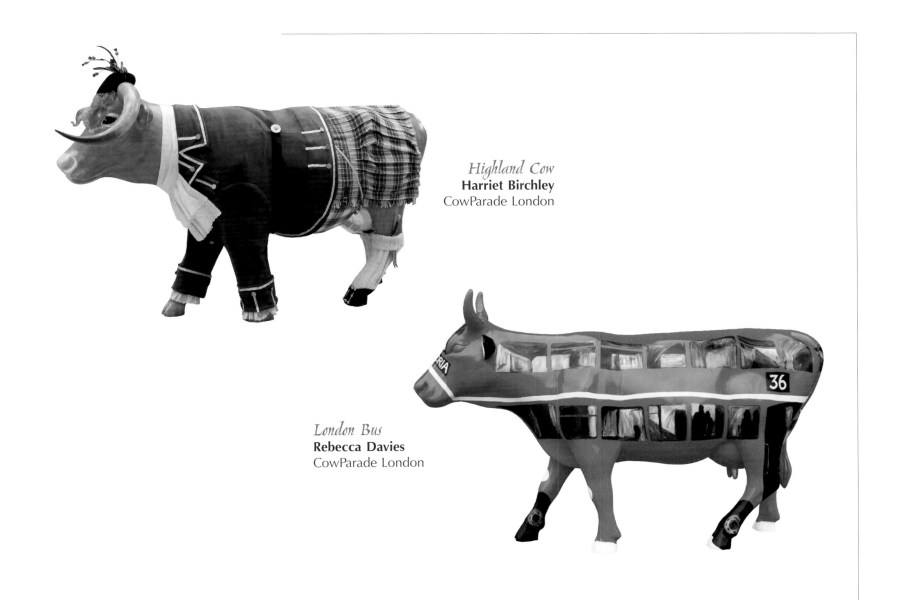

Highland Cow
Harriet Birchley
CowParade London

London Bus
Rebecca Davies
CowParade London

Ventspils, Latvia 2002

Ventspils, a small city located on Latvia's northwest coast, is the first eastern European city to host a CowParade. Featuring 26 cows, Ventspils was home to some of CowParade's most creative and unique works yet. The event, scheduled to run from June to August 2002, was so popular it was extended for an additional three months. The 26 cows were auctioned at the conclusion of the event for the benefit of the Ventspils Fund of Promotion of Education and Development of Children and Youth.

Latvian Black (*Latvijas Melnā*)
Kirils Pantelejevs

Top:
Milk Cow
Natalie Johnson

Bottom Left:
Essence
Andris Vitolins

Bottom Right:
Towards the Light (Pretim Gaismai)
Andres Bre•

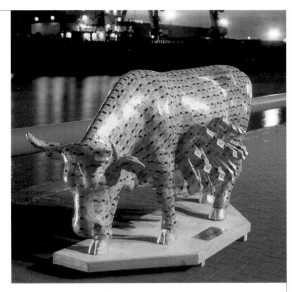

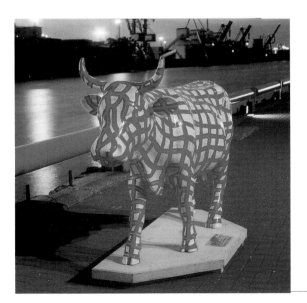

Portland, Oregon 2002

The CowParade Portland exhibition ran from April to July 2002. The event, consisting of 108 unique bovines painted by Portland-area artists, raised over $1 million for vital outreach, treatment, and prevention programs for children and families served by New Avenues for Youth, a Portland non-profit organization whose mission is to help homeless teens find permanent alternatives to street life, and Trillium Family Services, which is a union of three agencies: Children's Farm Home, Waverly Children's Home, and Parry Center for Children, all of which provide comprehensive care to seriously mentally and emotionally disturbed children and their families.

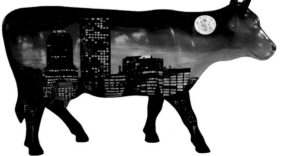

Mooon Over Portland
Jean O'Brien

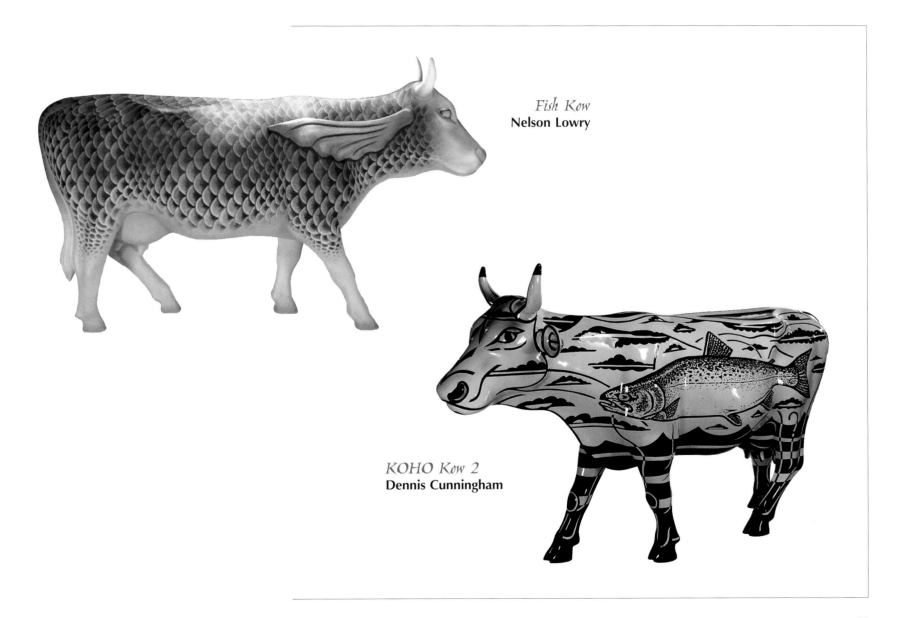

Fish Kow
Nelson Lowry

KOHO Kow 2
Dennis Cunningham

99

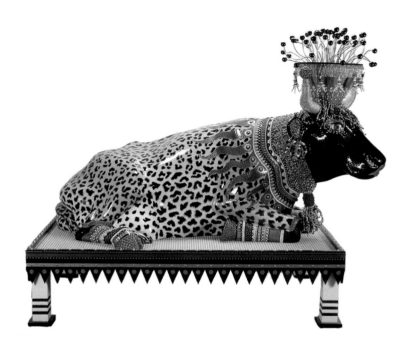

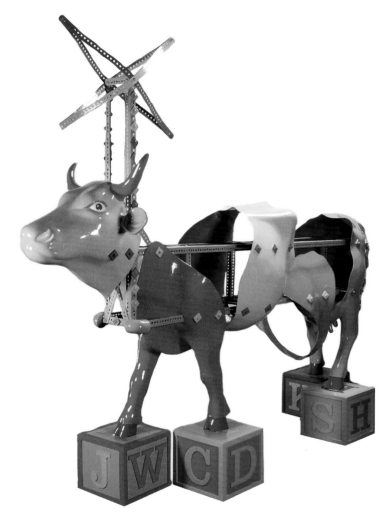

Top:
Nameless

Left:
Kids Kowstruction
Chris Keylock Williams

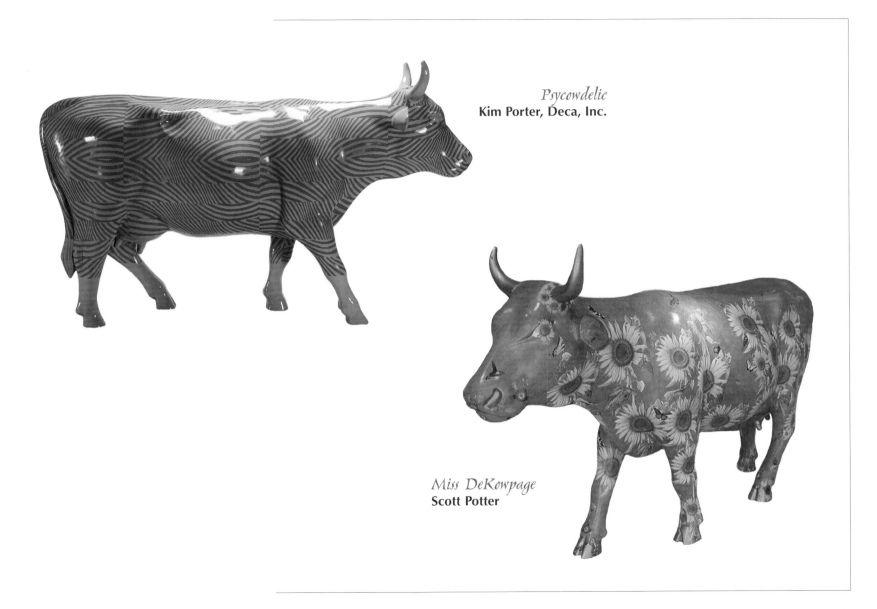

Psycowdelic
Kim Porter, Deca, Inc.

Miss DeKowpage
Scott Potter

Las Vegas, Nevada 2002

What would an event be without Siegfried & Roy, Howard Huges, Wayne Newton and the world's most famous sign? Well, it just wouldn't be Las Vegas. CowParade Las Vegas, staged in the fall and winter of 2002, featured over 60 new creations covering all of the classic Las Vegas icons, landmarks and themes.

Siegfried & Roy
Angelic Fedevich and Matt Kiovatch
Siegfried & Roy

Top Right:
Van Gogh's Vegas and Red Rock
Marybeth Butman
The Howard Hughes Corporation

Left:
Moo Moo in a Tu Tu
Silvestri California
Museum Company and Westland
Giftware

Bottom Right:
Howard Hooves
The Arts Factory
Landmark Broadcasting

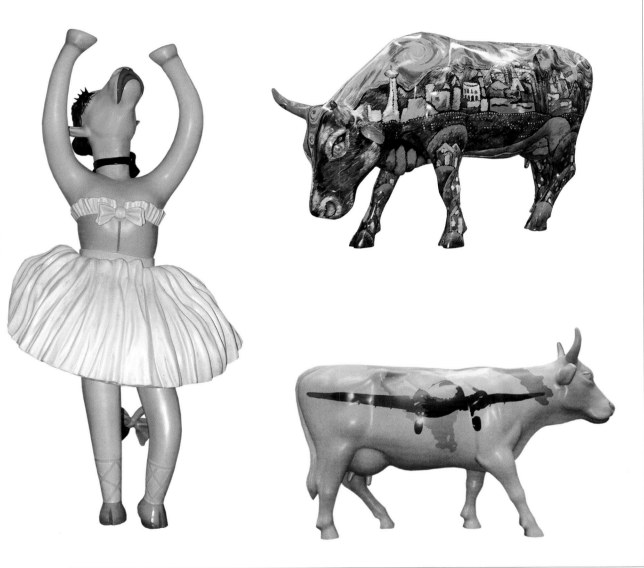

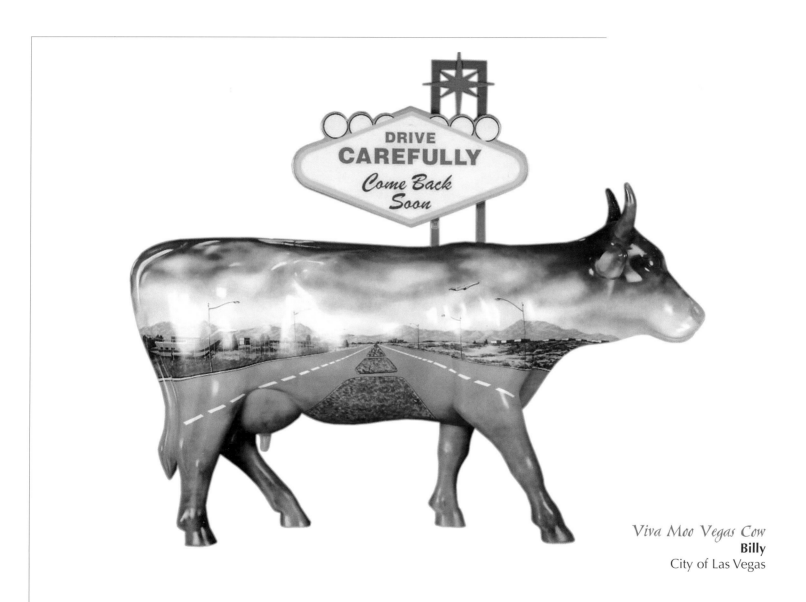

Viva Moo Vegas Cow
Billy
City of Las Vegas

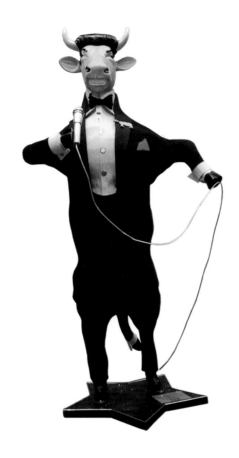

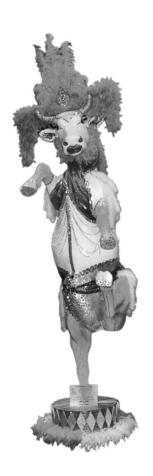

Wayne Mootan
Angelic Fedevich, Matt Kiovatch and Chris Barnes
Boyd Gaming Corporation

Bovina, The Las Vegas Showcow
Angelic Fedevich
Czarnowski Exhibition Services

San Antonio, Texas 2002–2003

Produced in conjunction with the American Cancer Society, the cows of CowParade San Antonio grazed in historic downtown San Antonio and greater San Antonio, including *Dairy Crockett*, who rightfully made her home on the grounds of the Alamo. San Antonio's artists made a collective stamp on Cowparade, weaving dinstinctively original styles of art and new cultural influences into the CowParade story.

Alamoo City
W.B. Thompson, Jr.
Cox and Smith

Top Right:
Moo-cho Caliente
Elias San Miquel
Le Peep Cafe

Bottom Right:
Texas Alamoo
Deb Carlson Wight
Cavendar Toyota

Bottom Left:
Dairy Crockett
Conni Brenner, Wendy Carter and aArtvarks.com
San Antonio Express-News

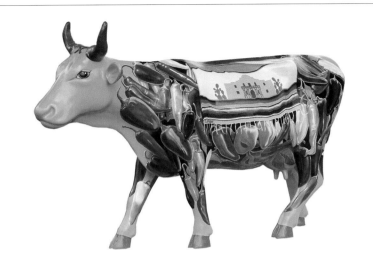

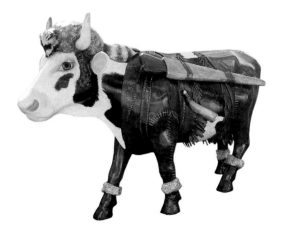

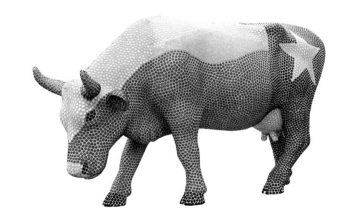

Auckland, New Zealand 2002–2003

CowParade really spanned the globe in 2002 when it brought the cows to Auckland, New Zealand. The event, featuring 32 cows, was held simultaneously with the America's Cup races, which drew 5 million visitors to the city. Proceeds from the auction of the Cows benefited Youthtown and its purchase of new computers for an after school program.

Buzzy Beef
Jill Jessup
First City Development

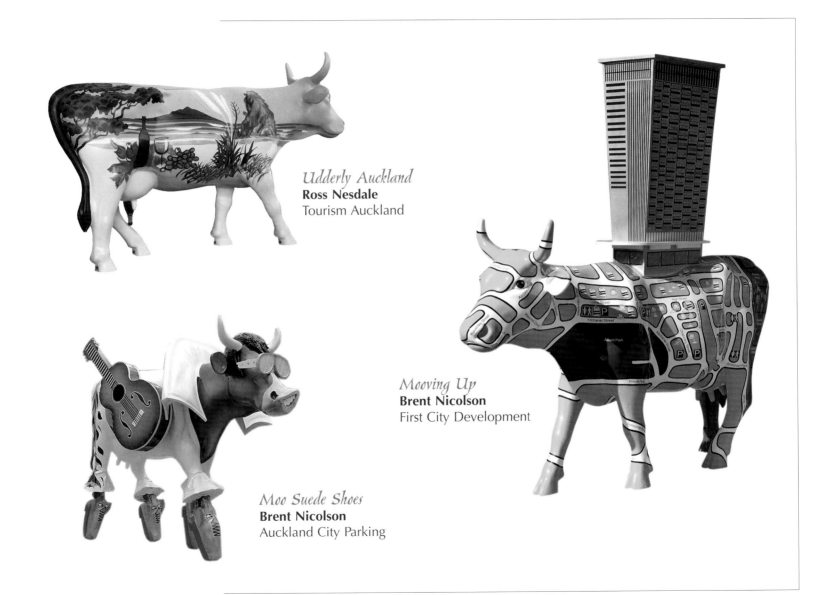

Udderly Auckland
Ross Nesdale
Tourism Auckland

Mooving Up
Brent Nicolson
First City Development

Moo Suede Shoes
Brent Nicolson
Auckland City Parking

Dublin, Ireland 2003

CowParade Dublin, presented by Bailey's, kicked off in June 2003 with 70 Irish bovines, including one produced by John Rocha, a leading Irish and International fashion designer. John produced a cow made from 15,000 pieces of hand-cut Waterford crystal, which were crafted onto the cow with a contemporary Celtic twist. Other cows include works from high-profile Irish artists including Graham Knuttel, Louise Kennedy, Robert Ballagh, Felim Egan, Deborah Donnelly, Rasher, Terry Bradley, Ronnie Woods of the Rolling Stones, Gavin Friday and Andrea Corr.

Absolutely Fresian
Sean Cooke
Bailey's

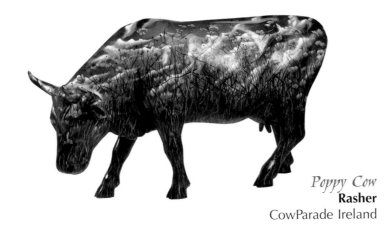

Poppy Cow
Rasher
CowParade Ireland

Hawte Cowisine
Mike Fitchher and Noah Stynes
Custom House Quay

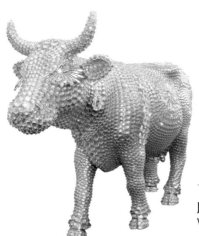

Waga-Moo-Moo
John Roca
Wagamamas

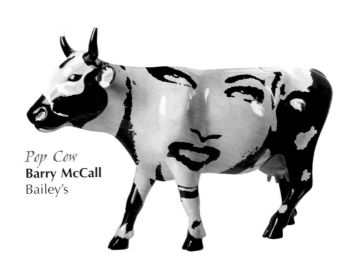

Pop Cow
Barry McCall
Bailey's

Isle of Mann 2003

The "udderly unique" Isle of Man (or Manx) played host to CowParade in the summer of 2003. The Island, home to approximately 75,000 residents, welcomed thirty-five cows painted by local artists. Manx, a self-governing kingdom located in the Irish Sea between England, Scotland, Ireland, and Wales, has its own parliament (called Tynwald), laws, traditions, culture, cuisine and postage stamps. The Three Legs of Man is the island's symbol of Independence. While there is much local argument about which way the legs run (officially it is clockwise), the symbol's meaning is undisputed: *Quocunque Jeceris Stabit*— 'Whichever way you throw me I stand'.

Moo Generation
Anna McChesney, Queen Elizabeth 2nd High School
Manx Electricity Authority

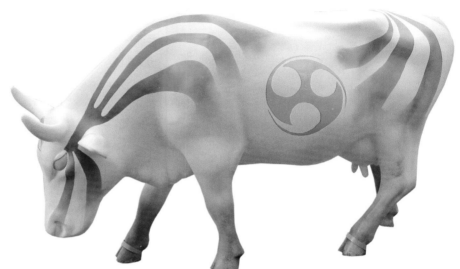

Betty
John Bennett, Isle of Man College
Betinternet

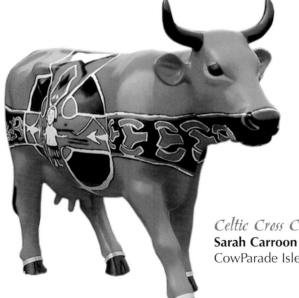

Celtic Cross Cow
Sarah Carroon
CowParade Isle of Man

Atlanta, Georgia 2003

CowParade made its Southeastern debut in Atlanta, Georgia in the summer of 2003. The world's largest and premier public art event got bigger and better with CowParade Atlanta, which featured 160 wild and creative cows. The Cows were sold through a live auction held at the Georgia World Congress Center in November 2003, with the remainder sold by an online auction. Proceeds from the event benefit the Southeast Division of the American Cancer Society and TechBridge, a non-profit organization providing high quality, subsidized technology consulting and development services to Georgia charitable organizations.

Atlanta Mootropolis
Rebecca Kunimoto & Lizbeth Harrison
Holder Construction

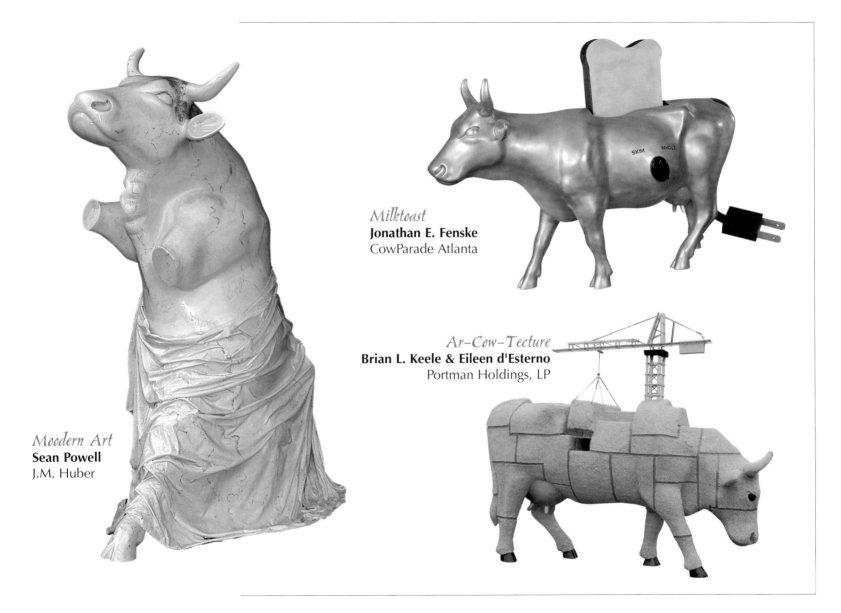

Milktoast
Jonathan E. Fenske
CowParade Atlanta

Ar-Cow-Tecture
Brian L. Keele & Eileen d'Esterno
Portman Holdings, LP

Moodern Art
Sean Powell
J.M. Huber

Tokyo, Japan 2003

The phenomenon of CowParade finally reached the Far East in 2003. Produced in a record time of three months, CowParade Tokyo presented by the Mitsubishi Estate Company took place in the Marunouchi section of the city and featured 64 original cows painted by some of Tokyo's most preeminent artists.

Keico

Flat Cow

Black Stroke

Triple Vision

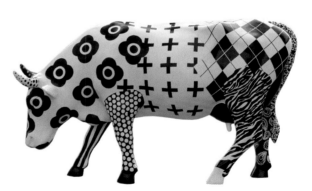

Stylish Cow

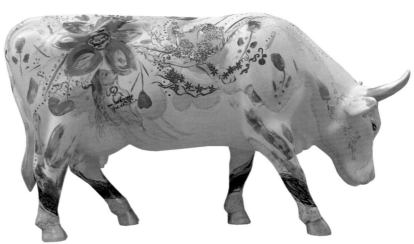

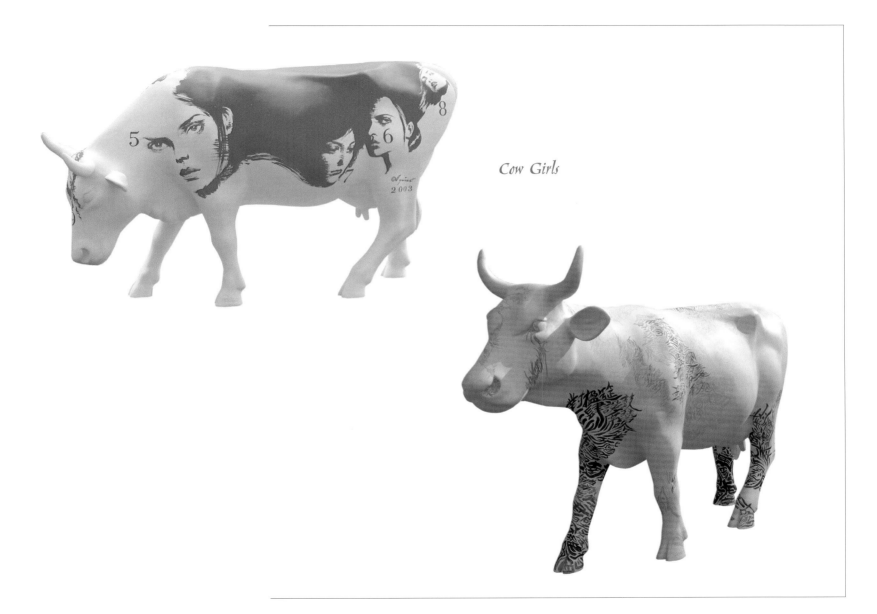

Cow Girls

Acknowledgments

PRESENTING SPONSOR
Guida's Milk & Ice Cream

GOLDEN BULL SPONSORS
Ginsburg Development Companies
Simons Real Estate Group, LLC

TOWN OF WEST HARTFORD
Mayor Jonathan Harris
Barry Feldman, Town Manager
Rob Rowlson, Business Development Officer
Renee McCue, Public Relations Specialist
Tom Larkum, Manager, Public Works

EVENT PRODUCTION
Event Manager
Ron Fox

Sponsorship Chair
Harriet Dobin

Art Program Coordinator
Marge Abrams

Logistics
Bruce Anderson
Jack Fyten

Cow Installation
Walker Crane & Rigging Company

Resident Artist and Chief Cow Surgeon
Scott Tao LaBossiere

Live Auction Printer
Finlay Printing

West Hartford Merchants Association
Robert La Perla, President

PUBLIC RELATIONS AND MARKETING
NRG Connecticut

MEDIA PARTNERS
NBC 30
Clear Channel Radio
ctnow.com
Hartford Magazine

CowParade West Hartford was the culmination of months of hard work by literally hundreds of volunteers and supporters. There are so many of these helping hands, there is just not enough space to thank each of them by name. But let it be known, it was their support, enthusiasm, and their smiles that made this event a success.

Artist Index

Sponsor Index

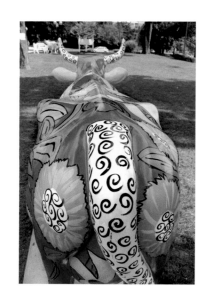